THE RELIGIOUS ART OF
ANDY WARHOL

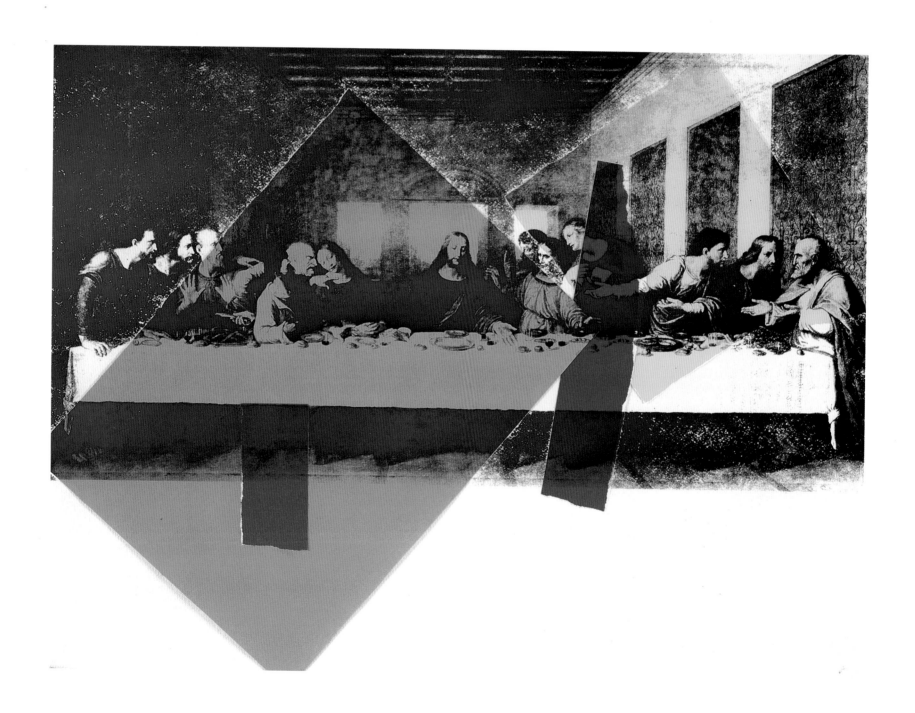

THE RELIGIOUS ART OF ANDY WARHOL

Jane Daggett Dillenberger

CONTINUUM · NEW YORK

The Continuum Publishing Company

370 Lexington Avenue

New York, NY 10017

Printed in Hong Kong

Book and cover design: Stefan Killen Design

Library of Congress Cataloging-in-Publication Data
Dillenberger, Jane.
 The religious art of Andy Warhol / Jane Daggett Dillenberger.
 p. cm.
 Includes bibliographical references.
 ISBN 0-8264-1112-6
 1. Warhol, Andy, 1928- —Criticism and interpretation.
 2. Warhol, Andy, 1928- —Religion. I. Warhol, Andy, 1928- .
 II Title.
 N6537.W28D56 1998
 709'.2—dc21 98-8483
 CIP

Dedication

To my colleagues and friends

John Richardson
John W. Cook
Robert Rosenblum
Tim Hunt
Michael Morris, O. P.

without whose spirited help this book could not have come into being.

Contents

Acknowledgments

I wish to express my gratitude to all those friends and colleagues who assisted me in countless ways in the preparation of this book:

Lynne Cooke, Martin Cribbs, Bonnie and Tom Farber, Mark Francis, Heiner Friedrich, Vincent Fremont, Gene Gollogly, Maurya Horgan, Doris Hickey, Margery King, Stefan Killen, Lisa Miriello, Frank Oveis, Jay Shriver, John W. Smith, Corinna Thierolf, Nicholas Ukrainiec, John Warhola, Paul and Anna Warhola, Matt Wrbican.

Funds for the research and publication were gratefully received from the Henry Luce Foundation, Inc. My thanks also go to the Graduate Theological Union, Berkeley, for a Faculty Grant and to the Center for the Arts and Religion and Education of the Graduate Theological Union.

Preface

A few months after Andy Warhol's death on February 22, 1987, *Vanity Fair* published an article by Andy's friend the art historian John Richardson. He told of some little-known aspects of Warhol's life—his ethnic and religious background—and he pictured Andy's very private life in his sedately and elegantly furnished New York townhouse. Among the accompanying photographs was one of Warhol's studio taken just after his death, showing a large painting by Warhol based on Leonardo da Vinci's *Last Supper*. The photograph was transfixing for me. I knew at once that Warhol must have done other such paintings. What were they like and where were they? Warhol, the Pop artist, the creator of religious art? Extraordinary!

I had been teaching, writing, and lecturing on the history of Judeo-Christian art for several decades. And I had been curator of two large traveling exhibitions on the history of American religious art. The first of these traced religious themes from colonial times to 1900; the second began with the early years of our century and included the abstract expressionists and the Pop artists George Segal and Robert Indiana. In the many months of concentrated research I had not discovered any evidence of religious art by Andy Warhol. Yet here was a large painting of the *Last Supper* on the wall of Warhol's studio.

I began immediately to track down the other paintings in this series. This meant intensive sleuthing, fitting together clues, and watching auctions, as well as working with colleagues at the Warhol Foundation and, after its opening, the Andy Warhol Museum. I found that Warhol had done at least twenty large paintings measuring from twenty-one to thirty-seven feet in width, all based on Leonardo's *Last Supper* and in addition a smaller series, as well as a large group of drawings and prints on paper, certainly totaling more than one hundred in all.

The *Last Supper* paintings appear to be Warhol's last series, and perhaps his largest. It is also, as Lynne Cooke remarked, arguably, his greatest series. Further, the *Last Supper* paintings are the largest series of religious art by any American artist. John Singer Sargent's murals for the Boston Public Library on the

theme of the history of religious thought from paganism to Christianity are the only cycle of works that rivals Warhol's series in size.

I am using the term *religious art* to refer to art with religious themes—in this case Christian themes. All Christian imagery and symbolism come to us weighted with roots in Judaic and other ancient religious sources; and Warhol, as a Byzantine Catholic, was heir to this Christian vocabulary.

A by-product of my search for Warhol's religious works has been the encounter with Warhol himself, in his own books and his countless interviews, and also in the mirrored image presented by his numerous and wildly various friends and associates. Complex, contradictory, enigmatic, he had a prodigious appetite for experiencing through seeing rather than active participation, whether it was social occasions or the work and the happenings in his work space called the Factory.

There are few artists who have left as massive a record as did Andy Warhol. Hundreds of photographs and self-portraits, film and television takes, and miles of tapes from the Sony recorder that accompanied him at work and at parties document him and his world. Warhol's public persona, his obsession with money, fame, and glamour, his voyeurism, and his unflappable coolness are well known. He has been viewed as immoral or amoral, and as an avaricious entrepreneur by many. Again and again colleagues have challenged me: How could such a dissolute and superficial artist produce genuinely religious art?

But there is another Andy, a private Andy, who is stunningly opposite to his public persona. This Andy is shy, reclusive, and religious. Hidden from all but his closest friends, John Richardson said, was "his spiritual side," and despite the fact that many "knew him in circumstances that were the antithesis of spiritual," that side existed in Andy and was the key to the artist's psyche. The enigma of Warhol's two-sided personality remains, but with some knowledge of the spiritual side of the artist, our viewing of his art is given another dimension.

Ultimately, however, it is the paintings that, when studied searchingly, yield up their burden of meaning and disclose their religious content. The chapters following the biographical sketch bring before the reader Warhol's beautiful, moving, exhilarating last works, a cycle of profoundly religious paintings by one of the great artists of the century.

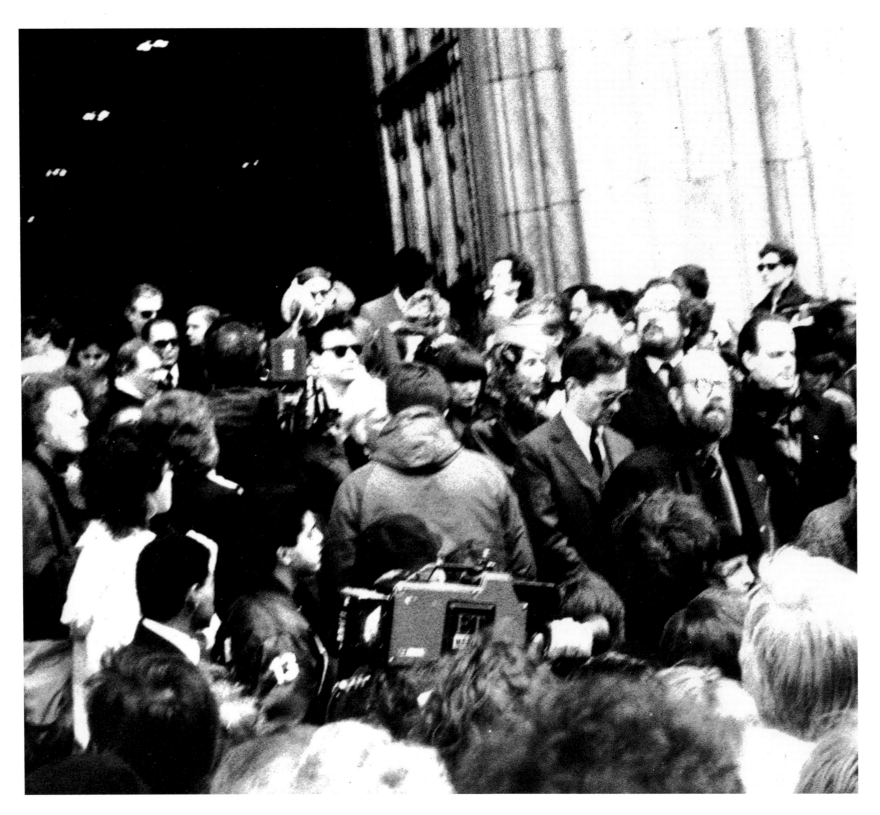

The Religious Art of Andy Warhol

Eulogy for Andy Warhol

By John Richardson

Given on the occasion of his memorial service at St. Patrick's Cathedral in New York City, April 1, 1987

Besides celebrating Andy Warhol as the quintessential artist of his time and place—the artist who held the most revealing mirror up to his generation—I'd like to recall a side of his character that he hid from all but his closest friends: his spiritual side. Those of you who knew him in circumstances that were the antithesis of spiritual may be surprised that such a side existed. But exist it did, and it's the key to the artist's psyche.

Never forget that Andy was born into a fervently Catholic family and brought up in the fervently Catholic *Ruska Dolina*, the Ruthenian section of Pittsburgh. As a youth, he was withdrawn and reclusive, devout and celibate; and beneath the disingenuous public mask that is how he at the heart remained. Thanks largely to the example of his adored mother, Julia, Andy never lost the habit of going to Mass more often than was obligatory. As fellow parishioners will remember, he made a point of dropping in on his local church, St. Vincent Ferrer, several days a week until shortly before he died.

Although Andy was perceived—with some justice—as a passive observer who never imposed his beliefs on other people, he could on occasion be an effective proselytizer. To my certain knowledge, he was responsible for at least one conversion. He took considerable pride in financing a nephew's studies for the priesthood. And as you have doubtless read on your Mass cards, he regularly helped out at a shelter serving meals to the homeless and the hungry. Trust Andy to have kept these activities very, very dark.

The knowledge of this secret piety inevitably changes our perception of an artist who fooled the world into believing that his only obsessions were money, fame, glamor, and that he was cool to the point of callousness. Never take Andy at face value. The callous observer was in fact a recording angel. And

1. The somber crowd and TV crew leaving St. Patrick's Cathedral, New York, after the Memorial Mass for Andy Warhol, April 1, 1987.

Andy's detachment—the distance he established between the world and himself—was above all a matter of innocence and of art. Isn't an artist usually obliged to step back from things? In his impregnable innocence and humility Andy always struck me as a *yurodstvo*—one of those saintly simpletons who haunt Russian fiction and Slavic villages, such as Mikova in Ruthenia, whence the Warhols stemmed. Hence his peculiar, passive power over people; his ability to remain uncorrupted, no matter what activities he chose to film, tape, or scrutinize. The saintly simpleton side likewise explains Andy's ever-increasing obsession with folklore and mysticism. He became more and more like a medieval alchemist searching—not so much for the philosopher's stone as for the elixer of youth.

If in the sixties some of the hangers-on at the Factory were hell-bent on destroying themselves, Andy was not to blame. He did what he could to help, but nothing in the world was going to deter those lemmings from their fate. In any case Andy was not cut out to be his brother's keeper. That would hardly have been compatible with the existent detachment which was his special gift. However, Andy *did* feel compassion, and he *did*, in his Prince Myshkin way, save many of his entourage from burnout.

Though ever in his thoughts, Andy's religion didn't surface in his work until two or three Christmases ago, when he embarked on his series of *Last Suppers,* many of them inspired by a cheap mock-up of Leonardo's masterpeice he bought on Times Square. Andy's use of a Pop concept to energize sacred subjects constitutes a major breakthrough in religious art. He even managed to give a slogan like "Jesus Saves" an uncanny new urgency. And how awesomely prophetic is Andy's painting—one of his very last—which announces: "Heaven and Hell Are Just One Breath Away!"

1: Another Andy Warhol

The knowledge of [his] secret piety inevitably changes our perception of an artist who fooled the world into believing that his only obsessions were money, fame, [and] glamor. . . .
—John Richardson, "Eulogy for Andy Warhol"

On April 1, 1987, the denizens of the art world, the rock and film worlds, the international jet set, and a throng of anonymous New Yorkers climbed the steps of St. Patrick's Cathedral to attend memorial services for Andy Warhol (fig. 1)—two thousand people in all. It did not escape Warhol's intimates that the service was on April Fool's Day. In his eulogy for Warhol, John Richardson likened Andy to the holy fool of Russian literature and culture.[1] This Slavic holy fool had a sense of humor and fun. Andy would have approved the choice of April Fool's Day for his last public memorial.

Of all New York churches, St. Patrick's Cathedral most embodies the spirit of the city. It was the proper location for Warhol's memorial service (fig. 2). He had come to New York, a twenty-year-old impecunious immigrant's son, but very soon became a successful commercial illustrator and then a renowned Pop artist: for over thirty-eight years New York was the locus of his very public life and of a vast number of activities embraced by the ever-burgeoning Andy Warhol Enterprises. For a lifelong devout Catholic who loved the city, New York's flagship church was the proper locus for Warhol's last rites, but an unusual spot for a memorial service for a contemporary artist. A secular funeral parlor was the usual place for such final ceremonies.

There must have been many who attended Andy's rites who learned for the first time of his lifelong church attendance and his personal piety, both of which he kept very, very secret. John Richardson spoke of the spiritual side of Andy Warhol, saying that though hidden from all but his closest friends, it was the key to the artist's psyche. He described Andy as a youth, as "withdrawn and reclusive, devout and celibate Thanks largely to the example of his adored mother, Julia, Andy never lost the habit of going

2. Program for the Warhol Memorial Mass at St. Patrick's Cathedral. Warhol's large, colorful painting *Raphael I–6.99* (1985), based on Raphael's well-known *Sistine Madonna,* was reproduced on the program. At the lower right is a statement by the rector of the Church of the Heavenly Rest in New York, who told of Andy Warhol's help in serving food to the homeless "with dedicated regularity."

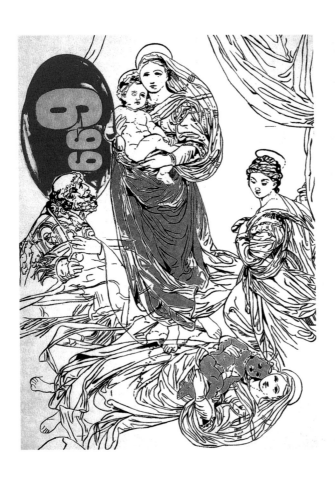

ANDY WARHOL

A Memorial Mass

Wednesday, April 1, 1987 – St. Patrick's Cathedral

Prelude	*March of the Priest – The Magic Flute* – Mozart Piano – Christopher O'Riley
	Louange a l'Immortalite de Jesu – Oliver Messiaen Cello – Carter Brey Piano – Christopher O'Riley
Scriptures	The Book of Wisdom 3: 1 – 9 Brigid Berlin
Speakers	John Richardson • Yoko Ono • Nicholas Love
Communion	
	Amazing Grace Soloist – Latasha Spencer
Postlude	*Recessional* – Ravel Piano – Christopher O'Riley • Barbara Weintraub
Celebrant	Father Anthony Dalla Villa, St. Patrick's Cathedral
	John Grady, Director of Music, St. Patrick's Cathedral

A LESSER-KNOWN ELEMENT IN THE PORTRAIT OF ANDY WARHOL

Five hundred homeless and hungry New Yorkers will assemble on Easter Day at the Church of the Heavenly Rest, on Fifth Avenue at 90th Street. They will be served a delicious meal, and they will be treated as honored guests by some eighty volunteers. They will also be saddened by the absence of one who, with dedicated regularity, greeted them on Thanksgiving, Christmas and Easter. Andy poured coffee, served food and helped clean up. More than that he was a true friend to these friendless. He loved these nameless New Yorkers and they loved him back. We will pause to remember Andy this Easter, confident that he will be feasting with us at a Heavenly Banquet, because he had heard another Homeless Person who said: "I was hungry and you gave me food…Truly, I say to you, as you did it to one of the least of these, my brothers and sisters, you did it to me."

The Reverend C. Hugh Hildesley, *Church of the Heavenly Rest*

Flowers to be donated to Mother Teresa – Missionaries of Charity, The Department of Parks – Forestry, and children's wards at various hospitals.

Raphael I – $6.99 Andy Warhol 1985

to Mass more often than is obligatory dropping in on his local church, St. Vincent Ferrer, several days a week until shortly before he died." Though his rags-to-riches story is in the American mold, Warhol's odd origin in a Ukrainian ghetto that was deeply rooted in Byzantine Catholic traditions is little known and yet was decisive in his life and art. It resulted in an undergirding piety and a lifelong habit of church going.

Two images of Andy Warhol exist in the popular press. In the 1960s he is the Warhol of his work space, the silver-coated Factory: a passive but ruling presence in black leather and dark glasses. The partying Andy of the 1970s was a figure in black tie and fright wig at the dinner table with movie stars, international celebrities, and even with three successive American presidents at the White House.

These images of Warhol belong to his public persona. The star-struck seeker after fame and fortune and the society of the rich and famous, the widely publicized "Pope of Pop," cannot be ignored, but it will be the background rather than the foreground of this account of Warhol's life. It is the private Andy Warhol, the spiritual side of this complex artist and his one hundred and more paintings of religious subjects that form the focus of the succeeding chapters.

In interviews and public appearances, Warhol showed a cool detachment and gave sly, terse, know-nothing responses. This was his camouflage. He wanted *not* to be known, as Henry Geldzahler, Warhol's longtime friend, said adding: "The facts of his biography were deliberately obscured by his extreme reluctance to reveal his own system of values. An amusing paradox with Andy is that for all his love of gossip and stardom he remained coy in the face of publicity, and the private meaning of his work." Geldzahler referred to Warhol as both "Mr. Mystery" and as "The Recording Angel."[2]

Facets of the enigmatic, complex, and endlessly fascinating person who was Andy Warhol shine from his work. No artist of our century or of past times is as prodigiously documented. His own books and interviews, his *Diaries,* and his taped conversations (he took his Sony tape recorder, "his wife," everywhere and recorded everything) provide a massive record. And yet who Andy Warhol was and is remains elusive.

Pittsburgh: The Ruska Dolina and Carnegie Tech

To understand Warhol's deeply rooted piety, it is essential to know something of the ambience and incidents of his childhood and upbringing. Andrew Warhola was born August 6, 1928, in a two-room shanty in a ghetto of Pittsburgh to Julia and Andrej Warhola, who were Carpatho-Rusyn immigrants from Mikova in the Slovak Republic of the former Czechoslovakia.[3] Andy's father, a construction worker, joined other Carpatho-Rusyn workers who had left the poverty and threatened conscription of their native Mikova for jobs in Pittsburgh. These Rusyn immigrants lived in the *Ruska Dolina*, the Ruthenian section of Pittsburgh, where life revolved around the Byzantine Catholic Church, which preserved the language and something of the culture and history of the land of their origin. These Rusyn Byzantine Catholics observed the ancient Eastern or Byzantine calendar, celebrating Christmas on January 7. Their distinctive church year and liturgy and their use of Old Slavonic in their churches set them apart from their Roman Catholic neighbors.

Andrej Warhola was a hard-working, thrifty, severe man who said prayers before meals and led the family on the six-mile walk to church for the Sunday liturgy. He then enforced a day of rest for all: Paul, the eldest of the Warhola sons, recalled: "You weren't even allowed to pick up a pair of scissors on Sunday—no playing, nothing. He was firm . . . if you didn't go to church on Sunday you didn't get out at all on that day. And we didn't have a radio or nothing. So whadya do? Mother used to tell us stories."[4]

John Warhola, the second son, observed that the immigrants who came from Eastern Europe had as their first priority their religion. He said that their mother "taught you she liked going to church better than material things."[5] Julia Warhola had brought with her many of the religious folk customs of her native home.

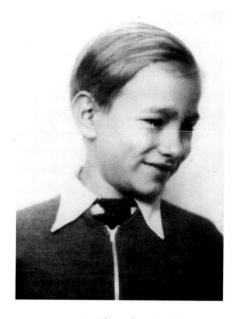

3. The eight-year-old Andrew Warhola. This snapshot was probably taken before the first of his three attacks of St. Vitus Dance, which caused shaking and disorientation. His pale face and white-blond hair gave him a fragile look, which made him the target of bullies and increased his tendency to withdraw.

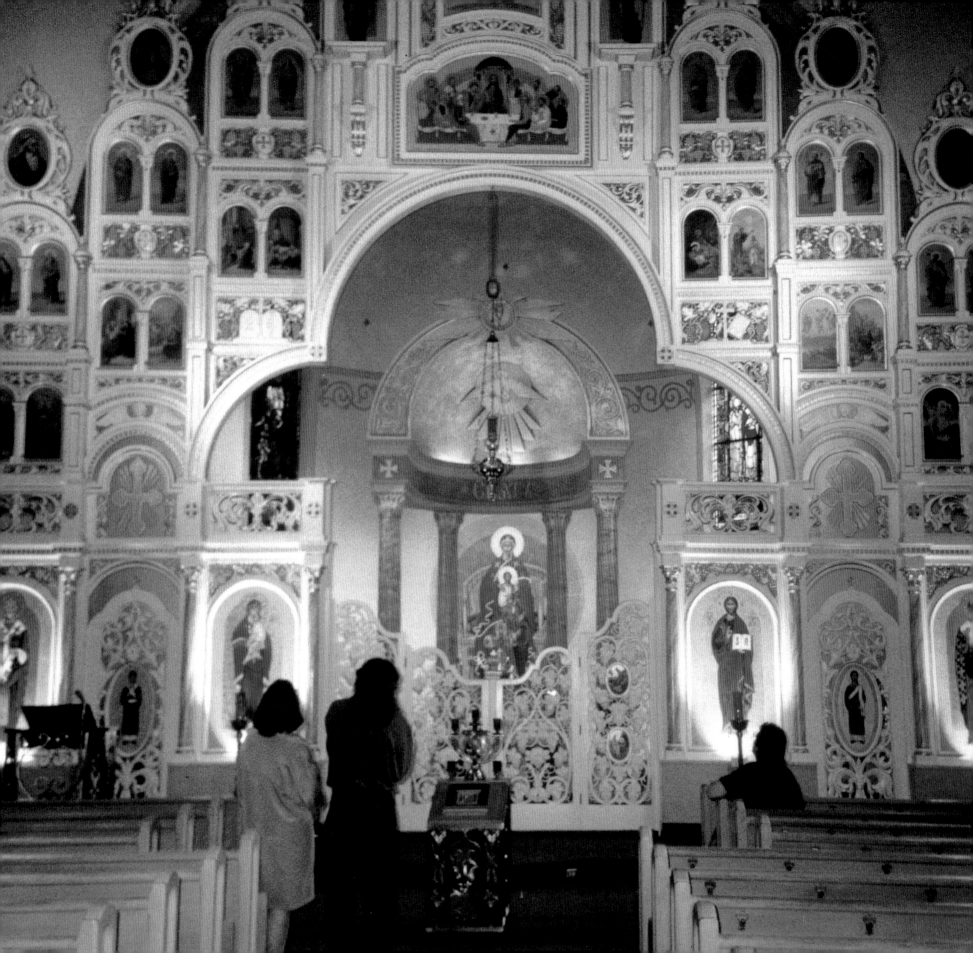

Andy (fig. 3), the youngest of Julia and Andrej's three boys, was baptized in St. John Chrysostom Byzantine Catholic Church, where the family regularly worshiped (fig. 4). From childhood through his college years, Andy attended the lengthy Byzantine church services before the colorful iconostasis screen with its multiple devotional images, along with the pomp and glitter of the processionals and the repetition of prayers and petitions, as incense rose amid the light and fragrance of many glowing candles.

Western Catholic churches have throughout the centuries surrounded the worshiper with a host of visual images, as in St. Patrick's in New York, where the many paintings and sculptures of saints and biblical events invite private devotions and contribute to the environment of worship. But the Carpatho-Rusyn Church's liturgy and form of worship derived from the Byzantine tradition, wherein a heightened veneration is accorded the visual image, the religious icon, which engages the viewer, having a function equivalent to that of scripture, for the icon mediates between the believer and the holy person represented by the icon. Thus, the presence and the kissing of icons are believed to be the context for contact with the divine.

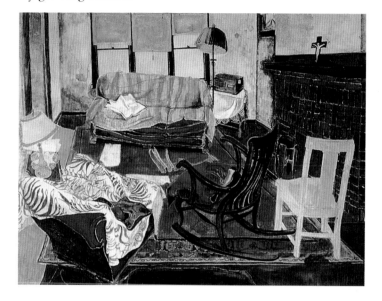

In the Warhola home most rooms had icons; Andy's brother, John Warhola reported that a picture of the *Last Supper* hung in the kitchen where the family ate.[6] One of Warhol's earliest paintings of the family living room (fig. 5) shows a crucifix on the mantle above the fireplace: Paul Warhola commented that Andy in this picture "left out Mother's holy pictures, but he put in the cross from Dad's funeral, on the fireplace where we always kept it."[7] Thus, Andy's earliest experience of art was of religious art—it may not have been very good art, but unlike for many Protestants or those outside the churches whose experience of religious art may have been limited to museums, for Andy, art and religion were linked from a very early age.

"When I was little I was sick a lot," Andy wrote in his amusing, off-beat book *The Philosophy of Andy Warhol*. He continued, in the fresh and candid style that was so characteristic of his conversation as well as his writing:

> I had three nervous breakdowns when I was a child, spaced a year apart. One when I was eight, one at nine, and one at ten. The attacks—St. Vitus Dance[8]—always started on the first day of summer vacation. I don't know what this meant. I would spend all summer listening to the radio and lying in bed with my Charlie McCarthy doll and my un-cut-out cut-out paper dolls all over the spread and under the pillow. My father was away a lot on business trips to the coal mines, so I never saw him very much. My mother would read to me in her thick Czechoslovakian accent as best she could, and I would always say

4. Overleaf: St. John Chrysostom Byzantine Catholic Church, Pittsburgh, Pennsylvania, where the Warhola family worshiped. Andy Warhol was baptized here and attended until age twenty-one, when he left for New York. Photograph by John Warhola.

5. Above: Andy Warhol, *The Warhola Livingroom*, 1946–47. Tempera and water-color on cardboard, 15 x 20 in. According to Paul Warhola, Warhol "left out Mother's holy pictures, but he put in the cross from Dad's funeral, on the fireplace where we always kept it."

"Thanks Mom," after she finished with Dick Tracy, even if I hadn't understood a word. She'd give me a Hershey Bar every time I finished a page in my coloring book.[9]

Warhol used a very simple syntax with a notable lack of adjectives, yet he often evoked a vivid picture, as he did here, of a young invalid amid his diversions with the attentions of a devoted mother who encouraged his art activities.

Family and friends report that Julia (fig. 6) had a special affection for her weaker, youngest son. Having artistic talent herself, she drew cats and other animals for him, and when he was eight years old his mother got him a child's movie projector out of her own earnings from cleaning and window washing; he used it to project comics on the wall. At the age of twelve he began to collect photographs of movie stars also. Such childhood collections are not unusual, of course, but in the case of Andy Warhol the early interest flowered twenty years later into the subject matter—the iconography—of Pop art by one of the originators of Pop.

Warhol's later preoccupation with death themes is certainly also related to childhood experiences. His father had tuberculosis and was ill and housebound from 1939 until his death in 1942.[10] The two older brothers were away much of the time, but Andy remained at home at his mother's side. His father's last illness was traumatic for Andy during his vulnerable early teens. Paul Warhola recalled that when his father's body was brought back from the hospital, Andy, terrified, hid under his bed and refused to look at the body, which was laid out, as was the custom of the Rusyn Byzantine Catholics, for three days in the Warhola home.[11] The recurrent theme of death in Warhol's paintings is thus rooted in the immediacy of this indelible childhood experience.

From the fifth grade on, Andy went to the free Saturday art classes at the Carnegie Museum. His teacher, Joseph Fitzpatrick, remembered the ten-year-old Andy as being a shy Slavic boy with a deft touch who was magnificently talented, personally not very attractive, and socially inept. But Fitzpatrick said he was very original and had a goal right from the start.[12] Classes at the Carnegie gave Andy his first exposure to traditional art, for ensconced in the ponderous and elegant Carnegie building were a collection of paintings and a splendid collection of casts of sculpture and architectural portals that spanned the ages.

He took art classes in high school, skipped the eleventh grade (he had skipped a grade in elementary school too), and was admitted to the Carnegie Institute of Technology at the age of sixteen. Despite the poverty of the Warhola's immigrant life, Andy's father had saved money designated for Andy to go to college. He could afford to send only one of his three sons, and apparently the entire family accepted that Andy's intelligence and sense of direction made him the candidate. Andy enrolled in the Department of Painting and Design and studied with faculty artists, among them Balcomb Greene, who taught him art history. Warhol won a number of prizes during the Carnegie Tech years and graduated in 1949.

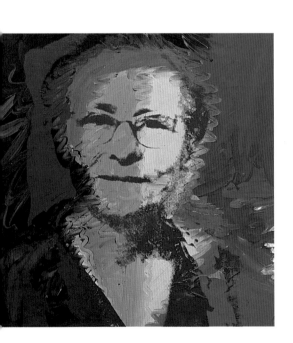

6. Andy Warhol, *Portrait of Julia Warhola*, 1974. Silkscreen on canvas, 40 x 40 in. Painted after her death.

The destitution of Warhol's early years left him with a permanent anxiety about money. Years later when Warhol was a wealthy man, in a rare, candid moment with Bob Colacello, he said, "Life isn't easy, Bob. I had to sell fruit on street corners to get through school, you know. It wasn't easy."[13]

Upon graduation Warhol moved to New York. At first he shared an apartment in the blue collar Ukrainian neighborhood with a fellow student at Carnegie Tech, the artist Philip Pearlstein.[14] The move from the ethnic enclave in Pittsburgh with its family and church ties to the freedom of the cosmopolitan city of New York might have resulted in Warhol's leaving behind his habitual churchgoing, but even when he was sharing a basement on 103rd Street with seventeen roommates, according to John Richardson, "He was forever popping into church."[15]

What Warhol did leave behind was the final *a* on his name. While he had signed his name A. Warhol on a drawing as early as 1942, in New York he adopted this form for good. "It just happened by itself," Warhol said, when he was going around with a portfolio looking for commercial design jobs. "People forgot to put it on, so, yeah, it just happened."[16] It seems to have been a matter of happenstance rather than a rejection of his ethnic origins.

In 1951 he was making enough money on commercial art projects to take a small apartment by himself; his devoted mother, Julia, moved in with him, bringing her three Siamese cats, her religious pictures, and her intense piety. Warhol told how she "had shown up one night at the apartment where I was living with a few suitcases, and shopping bags, and she announced that she'd left Pennsylvania for good 'to come live with my Andy.'"[17]

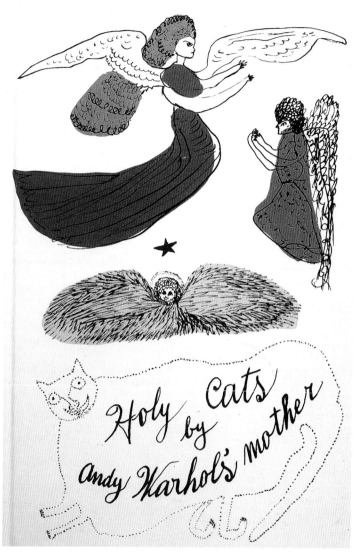

7. *Holy Cats by Andy Warhol's Mother.* Book cover, 9 x 6 in. The cover for Julia's fanciful book dedicated to her cat, "Little Hester who left for pussy heaven."

Before leaving home each day, Andy knelt and said prayers with her, in Old Slavonic. Andy wore a cross on a chain around his neck under his shirt and carried a pocket missal and rosary with him.[18] His mother kept crucifixes in the bedroom and kitchen, and she went to services regularly at St. Mary's Catholic Church of the Byzantine Rite. In Julia's yellowed and frayed Old Slavonic prayer book[19] there is a commemorative card (fig. 54) with a cheap reproduction of Leonardo da Vinci's *Last Supper,* which Andy must have often seen. This is a sentimentalized version of Leonardo's masterpiece, which Warhol recreated, using other copies of the original, in over a hundred paintings and drawings in the last years of his life.

Andy's mother lived with him for twenty years, until a few months before her death in 1972. Thus, Warhol lived in the ambience of her intense peasant piety for almost forty of his fifty-eight years.

Theirs was a close and symbiotic relationship. Few people were invited to Warhol's home, but friends who met his mother were asked quietly by Andy not to swear in her presence.[20] Fritzie Wood described Julia as childlike and having "a great joy to be alive and to be with Andy: he was the one quite obviously, close to her heart. She took great pride in him."[21] Julia Warhola seems to have been the central love of Warhol's life. His portrait of her, which was painted after her death, is remarkable for the affection and warmth with which Andy delineated her blunt features.

Just as Julia Warhola shared her piety with Andy, so she shared her artistic abilities. She did the lettering for many of Warhol's drawings and books in the early years, and she signed his name to many of his works. She and Andy together published two charming illustrated books on cats, hers being entitled *Holy Cats by Andy Warhol's Mother. Holy Cats* (fig. 7) is a whimsical, utterly enchanting work of folk art, in which angelic cats disport themselves among cherubs and angels in Julia's imagined "Pussy Heaven." She and Andy also did a full-sized folding screen, which she decorated on one side while Andy did the other side. Julia was Andy's first collaborator—the first of many.

In *The Philosophy of Andy Warhol,* Andy described himself in a succession of devastatingly candid phrases: "the puckish mask, the slightly Slavic look . . . the albino-chalk skin, parchment like, reptilian. Almost blue. The graying lips. The pinhead eyes. The long bony arms, so white they looked bleached . . . the arresting hands. . . ."[22] His hands were indeed striking: narrow, long-fingered, and capable of creating a precise and supple line or a painted replication of a commercial product that was photographic in its detail and finish.

The two idiosyncratic characteristics of Warhol's public persona—his outrageous wigs and his brief, know-nothing remarks—were both rooted in physical disabilities. Warhol began to lose his hair at an early age and started to wear hairpieces, and later as he became bald, outrageous wigs. Warhol always drew attention to his weaknesses rather than trying to conceal them, making a virtue of his vulnerability.

The other hallmark of the public Andy Warhol was his legendary silence at public events and his brief, often monosyllabic replies to interviewers: "Yeah, Oh, Gee . . . , I'm not sure, Really?" This was his strategy for dealing with his speech disorder, an inability to process human speech correctly. Warhol described the problem:

> I only know one language, and sometimes in the middle of a sentence I feel like a foreigner trying to talk it because I have word spasms where the parts of some words begin to sound peculiar to me and in the middle of saying the word I'll think, "Oh, this can't be right—this sounds very peculiar, I don't know if I should try to finish up this word or try to make it into something else, because if it comes out good it'll be right, but if it

comes out bad it'll sound retarded," so in the middle of words that are over one syllable, I sometimes get confused and try to graft other words on top of them. . . . Sometimes it's very embarrassing.[23]

It is ironic that in dealing with the uncertainty and confusion caused by this disorder, Warhol, who described himself as shy (and many of his close friends agreed) created a public persona that appeared cool, distanced, and unflappable, sometimes even impudent.

Art for Tiffany's and High Fashion Art

Throughout the 1950s and early 1960s Warhol did a variety of commercial art projects and book illustrations. Warhol had acquired a mastery of commercial techniques at Carnegie Tech, which, together with his great natural facility, originality, stylishness, and whimsical imagination, led to many jobs. He became a sought-after, successful illustrator of chic fashions, whose drawings often appeared in the *New York Times* and in fashion magazines.

For the most part the commercial artists and those who aspired to the world of "high" art worked in their separate worlds. Philip Pearlstein, Jasper Johns, and Robert Rauschenberg had all tried in their early years to get commercial work, but the latter two did it under other names. Warhol started out in the commercial world, working hard and cooperatively with his art editors, who were impressed by his flair, his fey humor, and his extraordinary originality. His work was much in demand by many well-known firms—Bonwit Teller, I. Miller Shoes, *Harper's Bazaar, Glamour* magazine, as well as Tiffany & Co.

Simultaneously in the fifties Warhol was making and exhibiting drawings in galleries. His first solo exhibition in New York in 1952 was of drawings based on the writings of Truman Capote, and in 1954 the Bodley Gallery exhibited his *Drawings for a Boy Book.* Both exhibitions contained drawings with homoerotic content. From the early 1950s Warhol produced "certain works that are as remarkable for their excellence in articulating gay sensibility as for their technical and formal achievements," as Trevor Fairbrother wrote in the catalogue for a posthumous exhibition of Warhol's early art. He continued, "Warhol was no militant crusader for the gay movement, but he spent his life setting a subversive example of being what he believed in and refusing to wear a disguise. During the 50s figures prominent in the public eye rarely risked this bold stance."[24]

Warhol revealed in *Popism: The Warhol 60's* how Emile de Antonio (an artist's agent in the 1950s known for his films on Nixon and McCarthy) answered Warhol's query as to why Jasper Johns and Robert Rauschenberg avoided him: he said it was because Warhol was "too swishy" and that though these artists

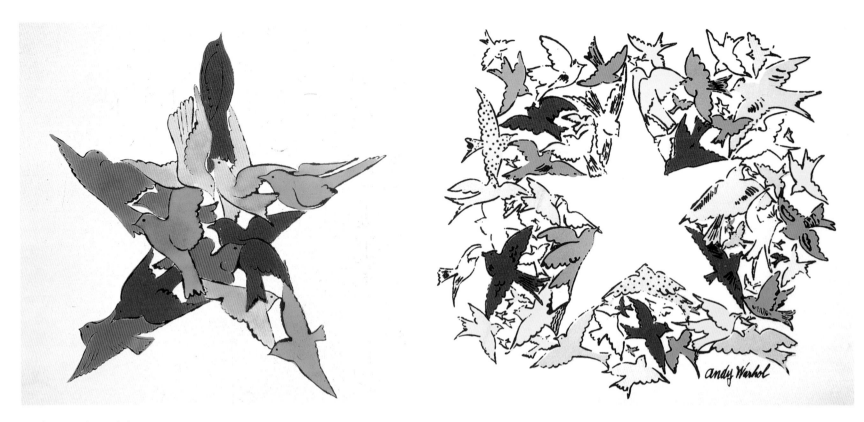

8. Above: Andy Warhol, *Untitled,* ca. 1958. Ink on paper, 22¹⁄₂ x 16³⁄₄ in. Christmas card design for Tiffany & Co.

9. Above left: Andy Warhol, *Star of Wonder,* ca. 1958. 5 x 6¹⁄₂ in. Christmas card designed for Tiffany & Co. Warhol's signature was done by Julia Warhol, who signed many of his early works in her spiky, old-fashioned script.

were both gay, in the 1950s the major painters tried to look straight. Warhol's response was "as for the swish thing, I'd always had a lot of fun with that—just watching the expression on people's faces. . . . I admit, I went out of my way to play up the other extreme."²⁵ Playfulness and the impulse to shock were both integral to Warhol's complex nature. Warhol's openly gay stance became an added facet of that carefully constructed, witty, cool, inscrutable public persona that is known through Warhol's self-promotion and through the media hype.

Warhol's early drawings of religious themes come from the years when he was working in New York as a commercial artist. For Tiffany & Co. he did a series of drawings for Christmas cards. Several charming drawings of a star show Warhol's fanciful variations on the theme *The Star of Wonder.* The title comes from the refrain of a familiar Christmastide hymn: "Star of wonder, star of night, star with royal beauty bright. . . ." Red roses, a flower associated with the Madonna, compose the five-sided star in one drawing. Another drawing shows brilliantly colored birds clustered in a star shape. Tiffany & Co. chose a related drawing, and the card shows a star that is defined by the fluttering, wheeling birds surrounding it (fig. 8). Not only was "Designed by Andy Warhol for Tiffany & Co." printed on the back of the card, but also on the face of the card (fig. 9) "Andy Warhol" was inscribed in the spiky penmanship of his mother,

who signed many of his works in these years. Andy's renown in the world of commercial art and fashion gave his name value.

Warhol's beautiful drawing of a hand holding a Christmas crèche (fig. 10) shows both the fanciful originality of Warhol's imagination and the evidence of his knowledge of art of the past. He frequented museums and galleries, had his own collection of clippings from art and fashion magazines and catalogues, and also used the vast clipping files found in the New York Public Library. In this drawing of a golden hand holding the tiny crèche within its palm, the Virgin is seated on the ground with the nude Christ child lying across her knees—a type called the Virgin of Humility, which originated in Sienese fourteenth-century art. The slender columns supporting a pitched roof and the wattle fence are found in paintings like Giovanni di Paolo's *Adoration of the Magi* in the Metropolitan Museum, which Warhol must have seen. The drawing is encrusted with commercially confected, gold-embossed decorations used for the halo of the Virgin, the cherub who flutters above, the star, and the leaves in the foreground. The golden hand gently supports its little burden: one recognizes Andy's narrow, long-fingered hand, which curves protectively about the Virgin and Child. The intimacy with which the crèche rests within the palm suggests Warhol's longtime familiarity with the theme. In Warhol's home the Christmas celebrations included folk ceremonies and customs brought by his parents from Mikova in the Slovak Republic. The Christmas crèche was familiar from the holiday ceremonies of these early years.

These designs are Warhol's earliest professional work with religious imagery. They have an originality that was Warhol's—a striking freshness of line and color and form that makes them memorable, when so many Christmas cards are momentary in their appeal. Warhol did other drawings of cherubs, angels, and colorful traditional images of the Adoration of the Magi with embossed gold motifs. Perhaps these were intended for Tiffany's as well.[26]

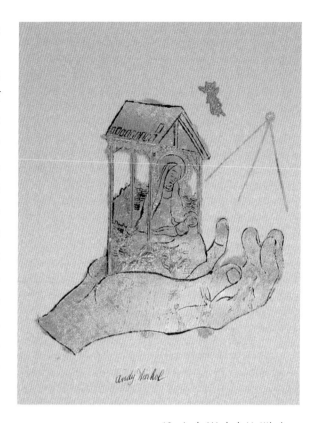

10. Andy Warhol, *Untitled* (Golden Hand with Crèche), 1957. Ink, gold leaf, and collage on paper, 18 x 14 in. Warhol's own long-fingered hand holds a little crèche, suggesting his familiarity with the Christmas folk ceremonies brought by his parents from Mikova in the Slovak Republic.

Warhol's First Pop Paintings

Warhol continued doing commercial work into the early sixties, but in 1960 he did his first Pop paintings, which soon afterwards catapulted him into fame. The term *Pop* had not been used yet, but these paintings, based on comics and advertisements, heralded a new and revolutionary kind of art. The artists of the preceding generation, the abstract expressionists, had departed from the traditional landscapes, portraits, still lifes, and depictions of historical events, exploring instead the impalpable— paths of energy, fields of spirit, and the mysteries of creation.[27] Their intention was to evoke the Sublime, an aesthetic category that

goes back to Edmund Burke (1729–1797), the author of the influential, pioneering study of the psychological basis of aesthetic enjoyment, *A Philosophical Inquiry into the Origin of Our Ideas of the Sublime and the Beautiful.* The abstract expressionists emphasized the uniqueness of each particular work of art with their exquisite impassioned brush strokes on large unframed canvases.

Warhol's *Superman, Dick Tracy,* and *Popeye* were dramatically antithetical to the work of the abstract expressionists. These popular images, appropriated from the comics, were enlarged and copied using the flat commercial colors of the comic strip. Both the image and the technique came from popular commercial art and lacked the uniqueness and elegant brushwork valued in the so-called high art of the preceding generation of artists such as Barnett Newman, Mark Rothko, Adolph Gottlieb, and Clifford Still.

In *Popism: The Warhol 60's,* Warhol told of the beginnings of the Pop movement:

> The Pop artists did images that anybody walking down Broadway could recognize in a split second—comics, picnic tables, men's trousers, celebrities, shower curtains, refrigerators, Coke bottles—all the great modern things that the Abstract Expressionists tried so hard not to notice at all.
>
> One of the phenomenal things about the Pop painters is that they were already painting alike when they met. My friend Henry Geldzahler, curator of twentieth century art at the Metropolitan Museum before he was appointed official culture czar of New York, once described the beginnings of Pop artists in this way: . . . in different parts of the city, unknown to each other, [you were] rising up out of the muck and staggering forward with your paintings in front of you.[28]

Warhol's early Pop works were hand painted, but by 1962 he had begun to use silkscreens to print images on canvas. Silkscreen had been used for commercial art and for posters, but now Warhol used it for art. Andy described the process:

> With silk screening you pick a photograph, blow it up, transfer it in glue onto silk and then roll the ink across it so that the ink goes through the silk and not the glue. That way you get the same image, slightly different each time. It was all so simple—quick and chancy. I was thrilled with it.[29]

So the artist's touch, the unique brushwork, the imprint of each of the artist's gestures as the paint surface was built up—all hallmarks of the abstract expressionist technique—were eliminated in favor of mechanical replication via the screens which bore the image. Andy himself spoke of wanting a

strong, assembly-line effect, but a number of photographs of Warhol working deny the cool, mechanical image of the artist. He is seen bending over the screens working with the intensity of focus and the utter absorption of the creative artist.

When the Pop artists were first shown, their work met with incomprehension, but when the paintings began to sell—and Leo Castelli's exhibition of Warhol's *Flower* paintings in 1964 sold out completely—the critics responded by questioning, and in some cases denouncing, the quality of the art and by querying the intentions of the artists. Hilton Kramer in 1962 saw Pop art as a juxtaposition of two clichés: a cliché of form superimposed on a cliché of images—that is, mass media images rendered in the style of mass production.[30] Another critic wrote that the works leave us thoroughly dissatisfied: most of them have nothing to say at all.[31] The Pop artists were accused of the passive acceptance of things as they are. The critics were not able to see these new paintings as Andy Warhol did, as the exuberant celebration of "all the great modern things." Pop art remained controversial for Warhol's entire career and even today can divide fair-minded critics. The artists were in no sense a self-conscious group or movement, and certainly Warhol, who was shy and often inarticulate, was no leader. But he was a magnetic, enigmatic artist dubbed by the media the Pope of Pop.

The variety and range of Warhol's work, which "anyone could recognize in a split second," present a mirror of the popular culture of our day: widely advertised items for consumption—Coca Cola, Campbell's soup (which Warhol had daily for lunch),[32] Pepsi Cola, hamburgers, Heinz Ketchup, and ubiquitous images such as comic book characters, movie stars, celebrities, and political leaders. Most of the images Warhol used were based on photographs, culled from newspapers or magazines. The photographs he used are straightforward and simple, but he had an uncanny sense for those that would have the greatest resonance. His manipulation of the photographs through the isolation of the image or its repetition; his sense of rhythm, of syncopation, of cropping, and of balancing the painted image with empty space transformed the original photograph into timeless, potent signs that have become indelible in the minds of millions. These images have become icons of contemporary culture, the things that surround us in supermarkets, on billboards, and in newspapers. But through Warhol's imaging of them they assume an autonomy and significance—they become totemic. As Andy Warhol said, "Pop Art is a way of liking things."[33]

When one surveys Warhol's paintings of the 1960s—from the perspective of a third of a century later—it becomes apparent that Warhol's subjects give more than an image bank of the times. They present serious social commentary: the paintings of suicides, car crashes, and race riots mirror the violence which permeates the culture. The portraits of politicians and celebrities, so secure in their success when they faced Andy's camera, are transformed by the revealing focus Andy's portraits brought to the very qualities that gave them their fame. Thirty years later it is the fragile and time-bound nature of these sub-

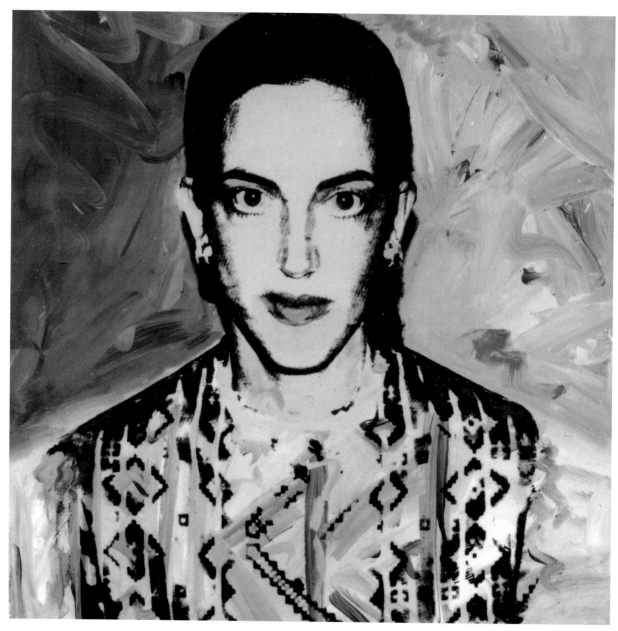

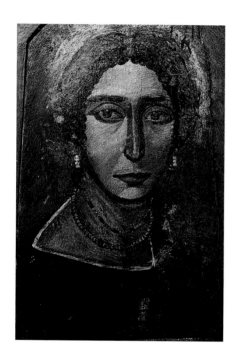

11. Above: *Fayum Portrait*, second to fourth century. Left: Andy Warhol, *Katie Jones*, 1973. Silkscreen on canvas, 40 x 40 in. It is the fragile and time-bound nature of their lives that gives poignancy to the faces Warhol portrayed: Katie Jones stares forth with something of the mute appeal seen in the eyes of the ancient portraits from Fayum, Egypt. The Fayum portraits were done for the mummy cases of the deceased, presumably before their death, since they bear evidence of individual identity.

jects' lives and fame that gives poignancy to their faces. Warhol's portrait of *Katie Jones* (fig. 11) (a member of the multi-millionaire Schlumberger family, whom Warhol knew socially) stares forth with something of the mute appeal seen in the eyes of the Egyptian Fayum coffin portraits. Done for the mummy cases of the deceased, the Fayum portraits were presumably painted before the deaths of the subjects, since they express so directly a sense of individual personality. Katie Jones's eyes, like those of the Fayum portraits, are riveting, claiming the moment but focused beyond time.

The Religious Art of Andy Warhol

The many items of food that Warhol painted with iconic directness preceded the general national concern for the hungry and the homeless. While Warhol was working on his huge series of paintings of the *Last Supper*, showing Jesus surrounded by his apostles at dinner before a table laden with bread, wine, and fish, Warhol himself was quietly helping to serve meals to the homeless at the Church of the Heavenly Rest in New York (fig. 12). In the *Diaries* Warhol says, "It's a different world. You see people with bad teeth and everything. And we're so used to all these beautiful perfect people. . . . It is such a great church, there was food for people to take home, too, and I was giving everybody a lot. If there's this many hungry people, there's really something wrong."[34] Andy's repeated assistance at the church for these holiday dinners for the poor was gratefully received: he persuaded some of his friends to help too, and when one of them became angry at the staff, Andy remonstrated, "Victor, we're here because we want to be here."[35] The poverty of his own early years must have come back to him, and he said that a lot of the ladies looked like his mother. It is a typically Warholian oddity that his fame began with *Campbell's Soup* paintings and at the end of his career it was in a soup kitchen that he found satisfaction in serving the homeless anonymously. Again the contradictions of this complex artist are apparent: Warhol's craving for fame but also for anonymity, and his choice of seemingly common and meaningless subjects which yet connected with a genuine concern for the hungry and homeless.

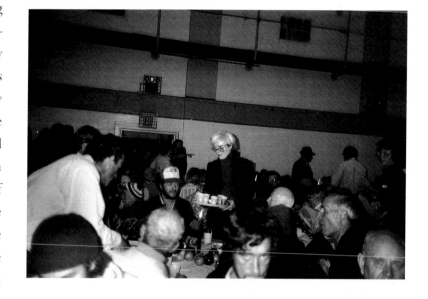

12. Warhol serving the homeless at the Church of the Heavenly Rest, New York. According to the rector, "Andy poured coffee, served food, and helped clean up. He was a true friend to these friendless. He loved these nameless New Yorkers and they loved him back."

In the 1960s Warhol expanded his artistic interests to other media. In 1963 he began making films while working on his Pop paintings, and in 1966 he began collaborating with the rock music group called "The Velvet Underground." The sixties were thus for Warhol a period of work in many media. In November 1963, Warhol moved all his painting equipment into a loft on East 47th Street that would soon become "the Factory." Billy Name (a.k.a. Billy Linich) covered the old walls with silver foil and silver paint. Filled with Warhol's art, music, and constant activity, the Factory attracted artists, college students, celebrities, New York lowlife and photographers who documented the scene.

Warhol included a picture of the Factory in his off-beat, charming little book *The Philosophy of Andy Warhol (From A to B and Back Again).* He remarked that in the sixties he was doing well professionally:

I had my own studio and a few people working for me, and an arrangement evolved where they actually lived at my work studio. In those days everything was loose, flexible. The people in the studio were there night and day. Maria Callas was always on the phonograph and there were lots of mirrors and a lot of tinfoil. . . . I had a lot of work to

do, a lot of canvases to stretch. I worked from ten a.m. to ten p.m. usually, going home to sleep and coming back in the morning. The same people I'd left there the night before were still there going strong, still with Maria and the mirrors. . . .

Famous people had started to come by the studio, to peek at the on-going party, I suppose—Kerouac, Ginsberg, Fonda, Hopper, Barnett Newman, Judy Garland, the Rolling Stones.[36]

The ongoing party also attracted speed freaks, acid heads, and those on the edge of insanity. Warhol himself had, as John Richardson said, the detachment of a recording angel rather than the callousness of a voyeur. Richardson went on to say, "To me Andy always seemed other worldly, almost priest-like in his ability to remain untainted by the speed freaks, leather boys, and drag queens, whom he attracted. . . . Andy was born with an innocence and humility that was impregnable—his Slavic spirituality like the Russian holy fool, the simpleton whose quasi-divine naïveté protects him against an inimical world."[37]

Warhol's fame turned to notoriety during the later sixties. It was during this period that a woman took out a gun and shot a hole through four *Marilyn* paintings that were leaning against the wall. And in 1967 a man entered the Factory with a gun and threatened Warhol and a group of Factory regulars. Fortunately his first shot did not fire, and after a wild second shot, he was apprehended.

"I Shot Andy Warhol"

The dramatic climax of this period came when one of Warhol's former film stars, the deranged Valerie Solanas, walked into the Factory on June 3, 1968, and fired three shots at him at close range (fig. 13). She had had a part in one of Warhol's movies. She was a radical feminist and lesbian who sold her *SCUM Manifesto* (Society for Cutting Up Men) on the streets, and who had written a script and given it to Andy, hoping he would film it. Warhol described the assassination attempt:

> I was putting the phone down, I heard a loud exploding noise and whirled around: I saw Valerie pointing the gun at me and realized she'd just fired it.
>
> I said, "No! No, Valerie! Don't do it!" and she shot at me again. I dropped down to the floor as if I'd been hit—I didn't know if I actually was or not. I tried to crawl under the desk. She moved in closer, fired again, and then I felt horrible, horrible pain, like a cherry bomb exploding inside me.

As I lay there, I watched blood come through my shirt and I heard more shooting and yelling. (Later—a long time later—they told me that two bullets from a .32-caliber gun had gone through my stomach, liver, spleen, esophagus, left lung, and right lung.)

Then suddenly Billy was leaning over me. He hadn't been there during the shooting, he'd just come in. I looked up and I thought he was laughing, and that made me start to laugh, too, I can't explain why. But it hurt so much, and I told him, "Don't laugh, oh, please don't make me laugh." But he wasn't laughing, it turned out, he was crying.

It was almost a half-hour before the ambulance got there. I just stayed still on the floor, bleeding.[38]

Though at one point Warhol was declared dead, five hours of surgery saved his life. His recovery was slow, requiring two months in the hospital and further surgery. Bob Colacello said that in the hospital Warhol "promised God to go to church every Sunday if he lived and he kept to the letter of that promise."[39]

The event changed Warhol; he said:

It put a new perspective on my memories of all the nutty people I had spent so much time with; crazy people had always fascinated me because they were so creative—they were incapable of doing things normally . . . usually they would never hurt anybody, they were just disturbed themselves; but how would I ever know again which was which? The fear of getting shot again made me think that I'd never again talk to somebody whose eyes looked weird. But when I thought about that, I got confused, because it included almost everybody I really enjoyed![40]

The Factory, besides being a work space and a party place for interesting and odd people, had a darker side. It was the locus for drug experimentation and other deviations that led to addiction and self-destruction for some. Bob Colacello, Warhol's editor for his magazine *Interview,* said that Warhol himself flirted with coke but didn't take anywhere near as much as the rest of them.[41]

The fear of getting shot again made Warhol timid, and his Factory regulars became protective. The press coverage of the assassination attempt brought an unsavory notoriety to Warhol. The open-door policy of the Factory had changed when the location was moved to Union Square in 1968. The Factory was no longer a party and hang-out place. The exuberant spirit of the sixties had changed.

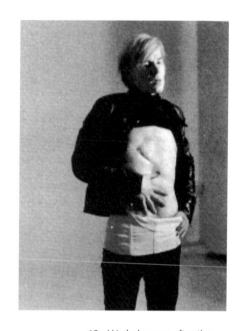

13. Warhol a year after the assassination attempt by Valerie Solanas. Warhol is seen, having pulled down the surgical corset he was obliged to wear, exposing the crisscrossing pattern of wounds from the two bullets fired at close range which penetrated his stomach, spleen, esophagus, and both lungs.

The 1970s

In 1970 a large retrospective of Warhol's paintings circulated from Pasadena to Chicago, Eindhoven, Paris, London, and then opened in New York at the Whitney Museum. It was the first occasion when the full range of Warhol's large and varied body of paintings could be seen and assessed. The quintessential Pop paintings *Campbell's Soup Cans, Coca Cola,* and *Dollar Bills* were there as well as the macho heroes *Elvis Presley* and *Marlon Brando.* But also there was a group of *Electric Chair* paintings that invited quiet and wonder at the beauty of their close-toned colors. A large room was entirely devoted to the *Flower* paintings, riotous and jubilant in color. It became apparent that Warhol was a great colorist.

It also became apparent that even before Warhol was shot, he had been preoccupied with the theme of death. The 1970 show included not only a series on the *Electric Chair* but also paintings based on newspaper and magazine photographs of suicides, fatal car crashes, and race riots. In addition, there were paintings of Marilyn Monroe, which Warhol did immediately upon hearing of her suicide. The death of the beautiful, vital, and popular star was vividly dramatized before a shocked public by the press and media. Warhol told of painting the *Marilyns,* "I realized that everything I was doing must have been death. It was Christmas or Labor Day—a holiday—and every time you turned on the radio they said something like '4 million people are going to die' [in automobile accidents]."[42]

During the seventies Warhol painted by day and partied by night. His studio assistants say that he was a workaholic, often the first person to arrive and the last to leave, and that he worked daily including weekends. Only such a regimen could account for the astonishing volume of his work in so many media. On into the 1970s Warhol made films and created multimedia events. In addition, he did from fifty to one hundred commissioned portraits a year. The roster included Truman Capote, Mick Jagger, Princess Caroline, Michael Jackson, the Shah of Iran, and other celebrities. Their faces can be seen not only in Warhol's striking, iconic portraits but also in photographs that Warhol and his entourage took of the parties he hosted or attended in these years.

In 1974 Warhol moved into a handsome townhouse at 57 East 66th Street which had been located for him by Jed Johnson, one of his helpers at the Factory. Jed, a gentle, handsome, and reticent young man from Sacramento, had begun sweeping floors at the Factory. During Warhol's convalescence from his surgery Jed Johnson brought the mail from the Factory and was helpful about the house. Eventually he moved in with Warhol and his mother when they were living on Lexington Avenue. Julia Warhola died November 22, 1972, and two years later Jed Johnson and Warhol occupied the 66th Street townhouse and Johnson discreetly and tastefully decorated the stately rooms. It was his first decorating job. He was to become a sought-after designer who worked with famous architects and clients. His Warhol connections helped bring him celebrity clients—Mick Jagger, Barbra Streisand, Richard Gere. His

career was tragically cut short by his death in the crash of TWA flight 800 over Long Island Sound in 1996.

Warhol had become an insatiable shopper and collector of fine furniture, art, and artifacts of all kinds. The elegant and formal rooms of Warhol's townhouse looked more like the residence of an Episcopal bishop than of this rakishly wigged Pop artist. Warhol, perhaps alone of all his contemporaries, never hung any of his own paintings in his home. The only original work by Warhol was "one of his wigs 'prettily' mounted in a Kulicke frame . . . like a cross between a large furry spider and a dahlia that has been squashed in a book."[43]

Warhol's bedroom, with its stately canopied bed (fig. 14) and splendid carpets, breathed an air of unostentatious luxury. On the bedside table, a santos carving, a crucifix,[44] a statuette of the Risen Christ (fig. 15), and a devotional book gave evidence of Warhol's religious practice. The book, *Heavenly Manna: A Practical Prayer Book of Devotions for Greek* [later editions replace "Greek" with "Byzantine"] *Catholics,* published in 1954 (now owned by John Warhola), shows Andy Warhol's markings of selected prayers. Warhol's piety was secret, as was also his home. Only his closest friends were ever invited in; Warhol usually entertained at restaurants.

During the 1970s, years of extraordinary productivity for Warhol in film, silkscreened works, his magazine, *Interview,* and the writing of his book *The Philosophy of Andy Warhol,* Andy lived quietly in his home and frequented the church of St. Vincent Ferrer for Sunday Mass and for several visits during the week. Father Sam Matarazzo, a Dominican and the prior of St. Vincent's, revealed in an interview that although Warhol never went to confession or communion, he visited the church two or three times a week and sat or knelt alone in the shadows at the back of the church. It was apparent that he did not want to be recognized. Father Matarazzo said that Warhol's spirituality was private even within the confines of this bustling parish church. Father Matarazzo speculated that "Warhol was bonding with a God and a Christ above and beyond the church"; he remarked that Warhol's life-style was "absolutely irreconcilable" with the teachings of the Catholic Church. Many gay men, he said, were in his congregation in spite of the fact that he preached the Catholic Church's opposition to homosexual practices frequently.[45]

St. Vincent Ferrer is on 66th Street and Lexington Avenue, only a few blocks from Warhol's elegant townhouse. The many altars with flickering candles burning before the images of saints and the Holy Family and its neo-Gothic sense of mystery must have appealed to Warhol, who in childhood had experienced worship at St. John Chrysostom in Pittsburgh before a golden iconostasis screen lit by many candles. Warhol's attendance at St. Vincent Ferrer was natural, since the Byzantine Catholic Church is in communion with the Roman Catholic Church. In the *Diaries* entry of April 22, 1984, however, Warhol noted that he did not go to church with friends, "because I would feel too peculiar in a church where they

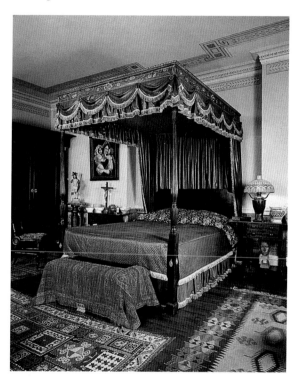

14. Warhol residence at 57 East 66th Street, New York. Warhol moved into this handsome townhouse in 1974. It was furnished with antiques and fine furniture, and was decorated with quiet dignity by Jed Johnson. Warhol had become an insatiable shopper and collector of fine furniture, art, and artifacts of all kinds.

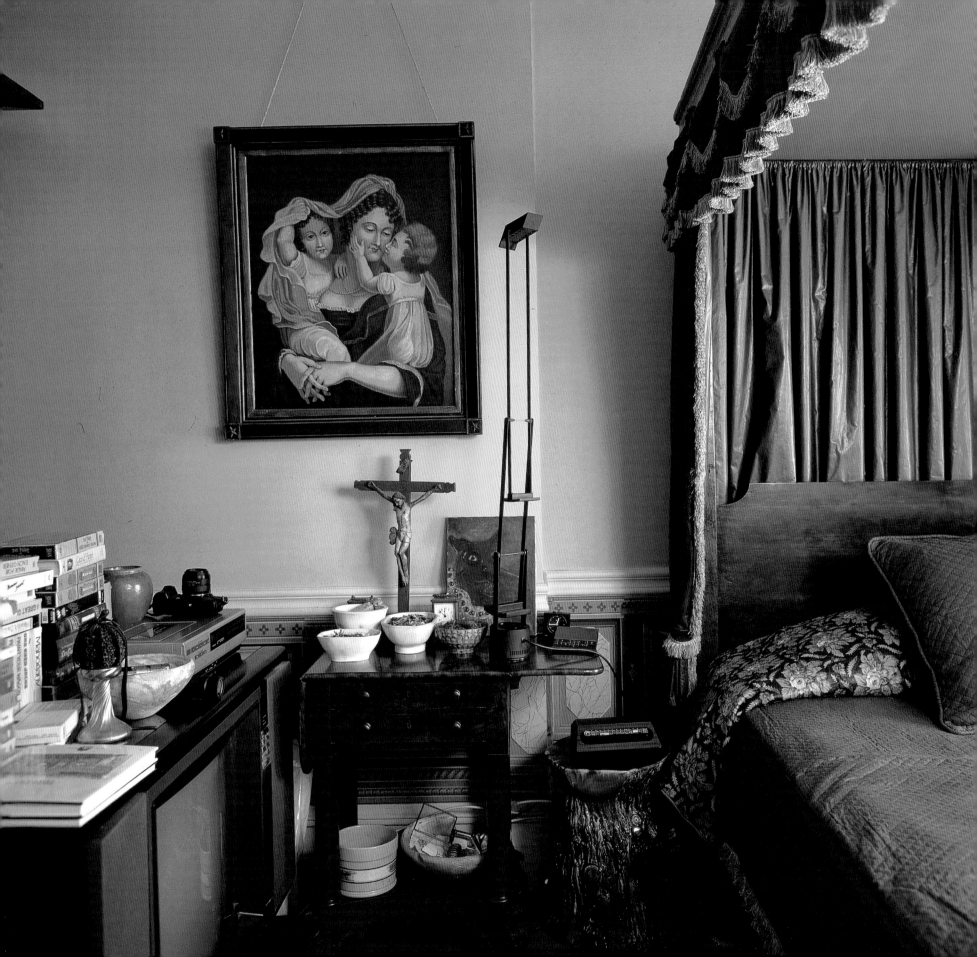

might see me praying and kneeling and crossing myself because I cross the wrong way, I cross the Orthodox way." (The Orthodox cross from right to left, rather than left to right.)

Warhol was open about his homosexuality and from the early 1950s produced drawings and illustrations that are technically fine and reveal a gay sensibility that ranged from the playful to the slyly suggestive to the explicit (fig. 16). He was unabashedly a voyeur and had occasional attachments to handsome men, some of whom lived with him for a period or traveled with him.

Some friends saw Jed Johnson's residence with Warhol as evidence of an amorous relationship, which Johnson neither denied nor admitted. Over the years Jed Johnson was not Warhol's only male companion; the question of these male relationships was the subject of an interview with Scott Cohen in 1980 at which Bob Colacello was present:

15. Overleaf: Warhol's elegantly draped antique bed. On the table nearby were a carved New Mexican crucifix, bowls of fragrant petals, and a devotional book marked by Warhol and given to his brother John Warhola before this photograph was taken.

16. Andy Warhol, *Reclining Man,* ca. 1956–57. Ballpoint pen on paper, 16¾ x 14 in. In 1956 Warhol exhibited a series of drawings, "Studies for a Boy Book." His homo-erotic drawings have beauty of line and an unabashed and sometimes playful sensuality.

S.C.: You're still a virgin?

A.W.: Yeah, I'm still a virgin.

S.C.: With all these beautiful people hanging around, don't you ever get turned on?

A.W.: Well, I think only kids who are very young should have sex, and people who aren't young should never get excited. After twenty-five you should look, but never touch.

Colacello continued with the query, "Was he still a virgin? I think technically he was. Whatever little sex he may have had in his fifty-two years was probably a mixture of masturbation and voyeurism—to use his word, *abstract.* Andy chose his words carefully and he knew that the opposite of abstract was figurative, concrete, real."[46]

Warhol's closest associates and helpers at the Factory (and then at the Office, as it was called when Andy Warhol Enterprises moved to 860 Broadway), were Catholics, but most were dropouts from the Catholic Church. Some of them report that they left Andy at the church, but that he went in alone. Bob Colacello told of going with him, when in Mexico, to the Shrine of the Virgin Guadalupe, the Mexican patron saint. Andy went through what he called "all the Catholic things"[47]—holy water, genuflecting, kneeling, praying, making the Sign of the Cross wherever specified in the Roman ritual. It was the first time Colacello had been in church with Andy, and he said he realized that Andy's religion "was not an act."[48]

From 1970 until his death in 1987, the number and geographic range of solo exhibitions of Warhol's work were vast. Amsterdam, Naples, Zurich, Geneva, Cologne, London, Paris, Munich, Tokyo, Vienna, Madrid, Rome, and Malmo, Sweden, as well as most sizable cities in this country. During this period Warhol continued to do film and television productions and his series of portraits of celebrities.

The Last Decade

Significantly, the decade before Warhol's death began with the creation of his *Skull* paintings of 1976 and ended with his 1986 series on the *Last Supper*. In this last decade he went from the theme of death and dissolution to the theme of redemption as imaged in the *Last Supper*, Jesus' last meal with his disciples, at which time he instituted the sacrament of the Eucharist.

In Warhol's *Diaries*, the published version of which begins in November of 1976 and continues through February 17, 1987, just five days before his death, his regular Sunday churchgoing was recorded, usually with the entry beginning, "Went to Church," before he launched into accounts of parties and gossip. But on occasion he did elaborate. Upon returning from a trip to Germany and Paris, Warhol's *Diaries* record, "I went to Church, gave my thanks for the trip and getting back alive."[49] Prayer was part of his life pattern, but so was the awareness of the fragility of life itself.

In 1980 Warhol went to Naples and Rome with Fred Hughes, who since 1967 had had a decisive and creative role in Andy Warhol Enterprises, as well as in Andy's social life. Hughes became a close associate and Warhol's exclusive agent and business manager. The *Diaries* entry for April 2, 1980, records their audience with Pope John Paul II (fig. 17).

> Fred and I had to leave for our private audience with the pope....We got our tickets and then the driver dropped us off at the Vatican....They finally took us to our seats with the rest of the 5,000 people and a nun screamed out, "You're Andy Warhol! Can I have your autograph?" She looked like Valerie Solanis [sic] so I got scared she'd pull out a gun and shoot me. Then I had to sign five more autographs for other nuns....Then finally the pope was coming our way. He shook everybody's hand and Fred kissed his ring and got Suzie's cross blessed...and he shook my hand and I said I was from New York, too. I didn't kiss his hand…. The mob behind us were jumping down from their seats, it was scary. As soon as Fred and I got blessed we ran out.[50]

The *Diaries* also tell of his appointments with Linda Li, a chiropractor and nutritionist, and with two "crystal doctors," both of whom were chiropractors. Warhol's diary entries about these New Age practitioners are filled with humor and show the dualism of both Warhol's skepticism and his credulity. Despite his questions, he was clearly fascinated with what he called their "hokum-pokum"[51] and several times affirmed the energy he experienced after his visits to them. He bought crystals that the crystal doctors programmed for him for particular purposes.

From August 1984 until his death, Warhol went to Dr. Li with some regularity, and the "crystal

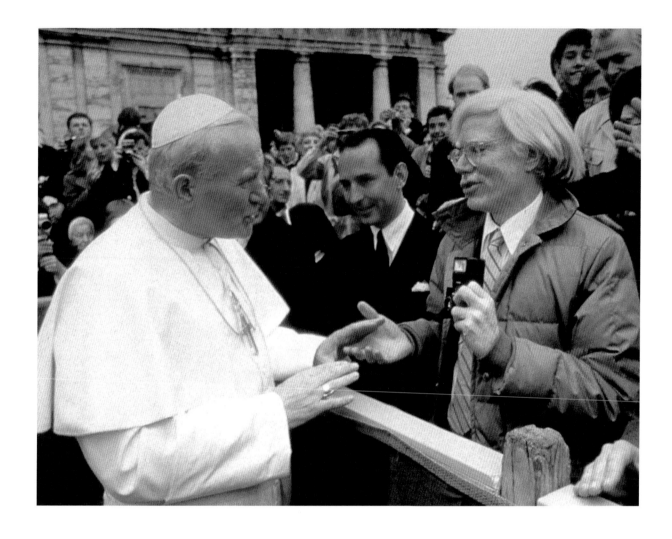

17. Warhol and Fred Hughes had an audience with Pope John Paul II on April 2, 1980. Warhol's *Diaries* give an account of the event, recording that he shook hands with the pope and was blessed by him, but that he left immediately afterwards because the surrounding mob was "scary."

doctors" on occasion. His own medical doctor had for some years recommended surgery for his diseased gall bladder, but Warhol resisted surgery, "gripped," as Stephen Koch observed, "by a phobic belief that he would not survive it."[52] When Warhol was shot in 1968, his heart had actually stopped beating on the operating table and, as Koch said, "in Warhol's sense of things, he had died and then been brought back, as if God had reconsidered and on second thought returned his life on loan. . . . He would live the rest of his life feeling a sense of metaphysical specialness and an accompanying metaphysical terror."[53] Koch's observation is reminiscent of the medieval tales of the horrors and fears experienced by Lazarus, whom Jesus had raised from the dead: Lazarus, having experienced death once, lived with the terror and fear of death's final claim.

All the while Warhol continued his regular attendance at St. Vincent Ferrer and recorded in his diary with relief that the "crystal doctor" Reese was an Episcopalian, adding that "somehow knowing he

believes in Christ I don't have to worry that crystals might be somehow against Christ."[54] This simple, matter-of-fact statement shows how deeply rooted Warhol's Christian faith was. It accords with John Richardson's description of Andy: "Andy always struck me as a *yurodstvo*—one of those saintly simpletons who haunt Russian fiction and Slavic villages, such as Mikova in Ruthenia, whence the Warhols stemmed. . . . The saintly simpleton side like-wise explains Andy's ever-increasing obsession with folklore and mysticism"[55]—and the power of crystal, one might add.

Warhol's involvement with the "crystal doctors" did not eclipse his religious regimen. His friend and phone pal of his last years, the photographer Christopher Makos, had traveled with Warhol to China, London, and many European cities and was with Andy in Milan for the opening of the *Last Supper* exhibition. In Makos's book of photographs of his travels with Andy, he wrote of Warhol's religious practice:

> Andy went to church every Sunday. A lot of his friends were Catholic. He may have related better to us Catholics because we all had the same background: mass, priests, nuns, Catholic school, a sense of guilt. His religion was a very private part of his life. In church he was Andrew Warhola and not a cool pop star Andy Warhol. I think it took a lot of pressure off him. It restored to him a perspective of the world that he had grown up with. In church he was the anonymous Catholic.[56]

It was in Warhol's last years that the paintings and prints with explicitly religious themes were done: the prints based on Renaissance religious paintings; the *Raphael I-6.99,* for which he used Raphael's well-known altarpiece the *Sistine Madonna;* the Cross paintings; and finally the large series of paintings based on Leonardo da Vinci's *Last Supper.* With the exception of the Cross paintings of 1982, all of these works with religious themes were done within the last two years of Warhol's life. They constitute a kind of last will and testament and were done in a period of intense activity, when Warhol worked with fervor and was on a creative roll, as Vincent Fremont, his long-time friend and business manager confirmed.[57]

On January 22, 1987, Warhol flew to Milan to attend the star-studded opening of the *Last Supper* exhibition held in a gallery right across the piazza from Santa Maria delle Grazie, which houses the Leonardo da Vinci *Last Supper,* which some believe has been overly scrupulously cleaned.

Photographs of Warhol taken at the opening show him smiling under his wig of silver hair, but he looks gaunt and glassy-eyed (fig. 71). Previously he had been diagnosed as having gall bladder problems. In Milan he had bouts of abdominal pain and left an extravagant dinner party early. Back in New York he went to chiropractor Linda Li. Finally, as the pain continued, he went to his regular internist, who advised immediate surgery for an enlarged and possibly gangrenous gall-bladder. Andy was checked into a New York hospital and, wanting to be anonymous, registered as Bob Roberts and stipulated no visitors.[58]

OUR LADY OF KORSUN

ER-03

✠

In Loving Memory of
Andy Warhol
Born August 6, 1928
Died February 22, 1987

PRAYER

O God, the Creator and Re-
deemer of all the faithful, grant
unto the souls of Thy servants
departed the remission of all their
sins; that, by pious supplications,
they may obtain that pardon
which they have always desired.
Grant this, O God, Who livest and
reignest for ever and ever. Amen.
 Eternal rest grant unto them,
O Lord, and let perpetual light
shine upon them. May they rest
in peace. Amen.
 Sweet Heart of Mary, be my
salvation! Mary, Mother of Per-
petual help pray for us.
 Our Father, — Hail Mary, —

Thomas P. Kunsak Funeral Home

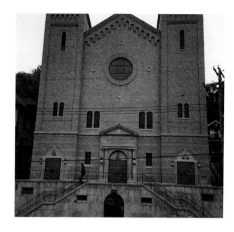

18. Left: Holy card for the Mass and Warhol's open-coffin wake at the Thomas P. Kunsak Funeral Home on Wednesday, February 25, 1987. Warhol was dressed in a black cashmere suit, a paisley tie, and one of his favorite platinum wigs. His brothers decided he should also wear sunglasses. "The sight of Andy lying in a white upholstered bronze coffin, holding a small black prayer book and a red rose struck one viewer as 'Warhol's final discomforting work.'"

19. Above: Holy Ghost Byzantine Catholic Church, Pittsburgh, where Warhol's funeral service was held, with prayers in English and Old High Slavonic.

Surgery the following day was successful, but at some point in the night his condition deteriorated suddenly, unnoticed by the private nurse until he had become blue and had only a feeble pulse. The emergency team was called but could not revive Warhol, who was pronounced dead at 6:30 a.m. on Sunday, February 22, 1987. The cause of death remains a mystery: an investigation by the hospital ensued, and the private nurse and hospital staff were criticized for neglect and incorrect procedures. The autopsy revealed no complications.

Andy's older brothers, John and Paul Warhola, came from Pittsburgh and arranged to have the body transported to Pittsburgh, where an open-coffin wake took place at a funeral home (fig. 18). Warhol was dressed in a black cashmere suit, a paisley tie, and one of his favorite platinum wigs. His brothers decided he should also wear sunglasses.[59] "The sight of Andy lying in a white upholstered bronze coffin, holding a small black prayer book and a red rose, struck one viewer as 'Warhol's final discomforting work.'"[60] On February 26, a Mass was said at the Holy Ghost Byzantine Catholic Church (fig. 19) with prayers in English and Old High Church Slavonic. Thereafter the coffin, covered by a blanket of white roses, was driven to St. John the Divine Byzantine Catholic Cemetery, some twenty miles away, where

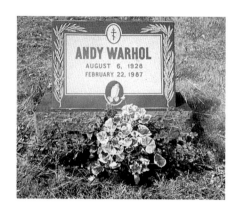

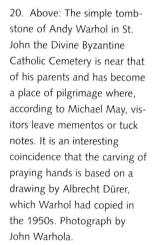

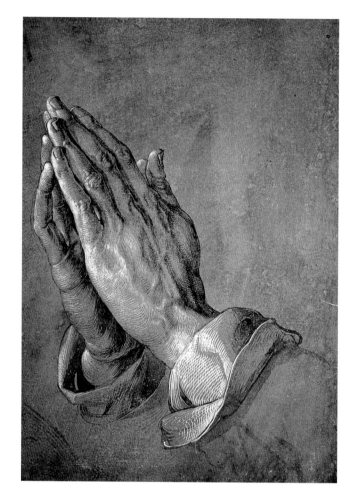

20. Above: The simple tombstone of Andy Warhol in St. John the Divine Byzantine Catholic Cemetery is near that of his parents and has become a place of pilgrimage where, according to Michael May, visitors leave mementos or tuck notes. It is an interesting coincidence that the carving of praying hands is based on a drawing by Albrecht Dürer, which Warhol had copied in the 1950s. Photograph by John Warhola.

21. Above left: Andy Warhol, *Praying Hands,* 1950s. Ink and dye on paper, 15 x 11¼ in. Albrecht Dürer, *Praying Hands,* ink and white paint on blue paper, 11½ x 7¾ in. Warhol's early drawing after Dürer's transformed the ascetic-looking hands of the German master into the supple, sensuous hands of a youth.

Andy's body was buried near his parents. The simple, indeed ordinary tombstone (fig. 20), had in addition to his name and dates the Byzantine cross with its three transverse arms, and a carving below based on Dürer's *Praying Hands,* in reverse (fig. 21). Warhol had previously done a drawing after Dürer's, transforming the narrow, bony, ascetic-looking hands of the German master into the supple, sensuous hands of a youth.

Andy had remarked in his book *America,* "I always thought I'd like my own tombstone to be blank. No epitaph and no name. Well actually, I'd like it to say 'figment.'"[61] Like so many of Warhol's aphorisms, this is one that is more astute than it appears. A figment, a pure invention, in some way characterizes this artist, who could and did reinvent himself. The successful and sought-after commercial artist of the fifties is followed by the sixties Warhol, the Pop artist; the seventies Warhol was the friend and painter of the rich and famous. Finally, there is the Warhol of the eighties, who partied, gossiped, and avidly collected, yet at the same time painted the late series of religious works of great beauty and gravitas.

Post Mortem

Andy Warhol was a great and conscious artist, and he's in heaven with Mozart and Balanchine.
—Henry Geldzahler, *Andy Warhol: A Memorial*

The funeral had been limited to Warhol's Pittsburgh family and a few close New York friends and associates, but the public homage to Andy took place on April 1 in St. Patrick's Cathedral in New York. Over two thousand people attended, among them many fellow artists—David Hockney, Richard Serra, Christo, Marisol, Claes Oldenberg, Roy Lichtenstein, Julian Schnabel, Francesco Clemente, Jean-Michel Basquiat, Keith Haring, Kenny Scharf, and Jamie Wyeth among others.

The invitation to the Memorial Mass at St. Patrick's reproduced Warhol's *Raphael I-6.99*, a painting based on Raphael's famous *Sistine Madonna*. Done in 1985, it was one of the first Warhol paintings with religious iconography. At the memorial service Andy's longtime friend Brigid Berlin read from scripture, and the art historian John Richardson gave the eulogy. Yoko Ono also spoke. Printed on the program was a statement titled "A Lesser Known Element in the Portrait of Andy Warhol," which told of the homeless people who "will also be saddened by the absence of one who, with dedicated regularity, greeted them on Thanksgiving, Christmas, and Easter. Andy poured coffee, served food, and helped clean up. More than that he was a true friend to these friendless. He loved these nameless New Yorkers and they loved him. . . ." The statement was signed by the Reverend Hugh Hildesley, Church of the Heavenly Rest, New York.

Warhol's will left the proceeds from the sale of his belongings to the Andy Warhol Foundation for the Visual Arts. Andy's twenty-seven room townhouse was sealed and Sotheby's auction house called to inventory the contents. Aside from his bedroom, the foyer, and the living room, every room was a storeroom for the vast collections of an unimaginable variety of fine art, artifacts, and "collectibles" that Andy had been buying, from Canova to cookie jars. Sotheby's produced a six-volume catalogue of Warhol holdings. The auction spanned a ten-day period and *Life* magazine called it the most extensive estate sale in history and one of the glitziest. It brought an astonishing 25.3 million dollars.

Subsequently the Warhol Foundation, together with the Dia Center for the Arts, which has long owned and exhibited Warhol's work, and the Carnegie Institute, established the Andy Warhol Museum in Pittsburgh for the exhibition of his work in all media The museum's collection of paintings, drawings, and prints by this prolific artist gives to the art world and the public their first opportunity to see the full range of Warhol's genius. Exhibitions of Warhol's work in this country have focused primarily on his early Pop works and his portraits of famous people. Even the Warhol retrospective held at the Museum of Modern Art after his death had two-thirds of the works from the first eight years of Warhol's twenty-six-year career as an artist. The paintings done by Warhol in the last years of his life are little known, since

22. Andy Warhol, *Heaven and Hell Are Just One Breath Away!*, ca. 1985–86. Silkscreen on canvas, 20x 16 in. Based on a flyer in Warhol's collection of source material, this premonitory exclamation was done during Warhol's last years.

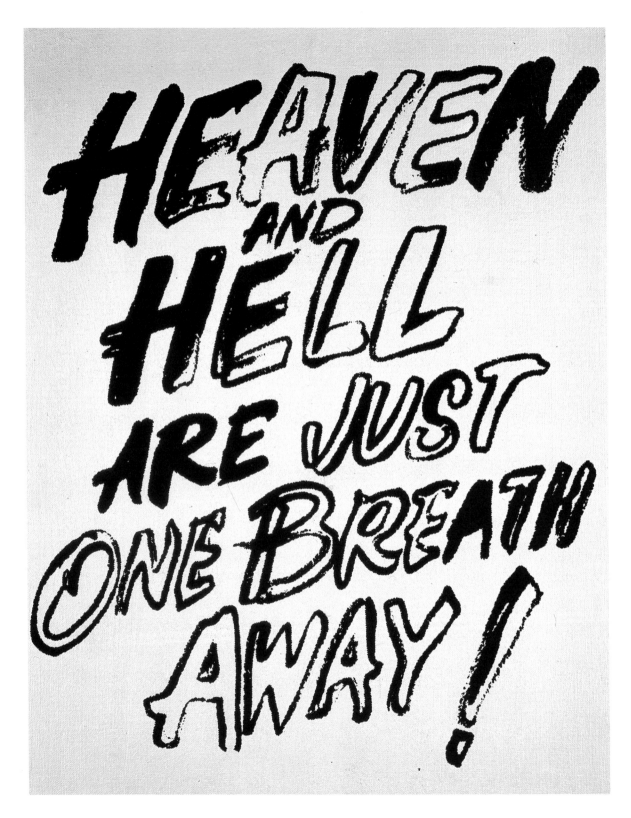

The Religious Art of Andy Warhol

they were exhibited abroad more often than in the United States. The grandeur of these late paintings can now be seen and experienced in settings designed for them in the museum in the city where Warhol was born and trained as an artist.

In these late paintings the seemingly distanced artist abandoned his cool stance. Warhol finally created paintings in which his secret but deeply religious nature flowed into his art. Technically he achieved a freedom and a virtuosity that are analogous to the mastery seen in the late work of some Renaissance and baroque masters. As with these earlier artists, Warhol's virtuosity served a profound spiritual vision (fig. 22). In the *Last Supper* paintings, he was engaged at a level deeper than his habitual piety. Warhol made new Leonardo's mural, recreating it and making it accessible to twentieth-century sensibilities, widening its meaning beyond the particularities of Christian belief to a more encompassing, universal affirmation.

23. Andy Warhol, *Cross* (Red), 1982. Synthetic polymer paint and silkscreen on canvas, 90 x 70 in.

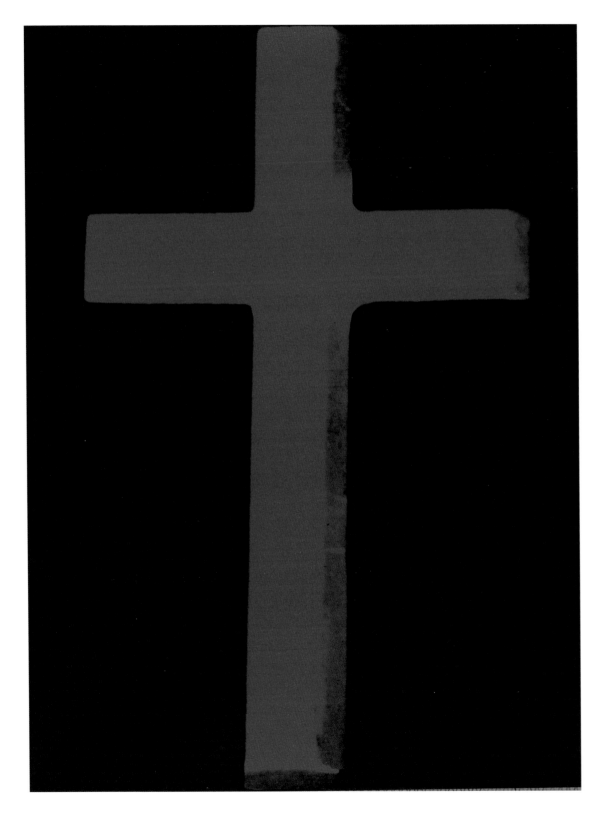

The Religious Art of Andy Warhol

2: From Crosses to Shadows: Warhol's First Religious Paintings

It is not surprising that this religious man got round to doing religious painting.
—John Richardson

Nothing in Warhol's previous work prepares the viewer for his astonishing first large religious painting, the scarlet *Cross* (fig. 23). Its grandeur, its spiritual resonance, and its sheer beauty are striking. The glowing *Cross* levitates against a velvety black background. The feathering of the black paint along the edge of the cross delineates its side and then merges into the encompassing blackness. Warhol, with his usual sense for drama, made the size of the painting taller than the average adult, and its width greater than the average arm span. Thus, the cross is large enough to bear an adult human body, but rather than suggesting the cross of crucifixion, this cross seems ethereal as it levitates before the viewer. It is a stunning painting, a joyous and breathtaking painting (fig. 24).

The scarlet *Cross* was based on a photograph of a simple, small wooden cross, the kind available at religious supply houses, which are said to be from the Holy Land or blessed by the pope. The Warhol Archives have a group of these small crosses that Warhol used in another series of paintings in which the small crosses were multicolored, arranged in rows or randomly placed (fig. 25).

They suggest the simple crosses used in military cemeteries, row on row, an appropriate association for the Spanish Civil War. The lively staccato pattern of the small crosses against a dark ground seems decorative and two-dimensional in contrast to the majesty of the large single *Cross* paintings. They were done for an exhibition in Madrid, a show entitled "Guns, Knives, and Crosses"—guns and knives for the Spanish Civil War, said Warhol, and crosses for "the Catholic thing."[1] The large *Cross* paintings were not part of this exhibition, though clearly they are based on photographs of one of the same devotional wooden crosses.

24. Andy Warhol, *Cross*
(Yellow), 1982. Synthetic
polymer paint and silkscreen
on canvas, 90 x 70 in.

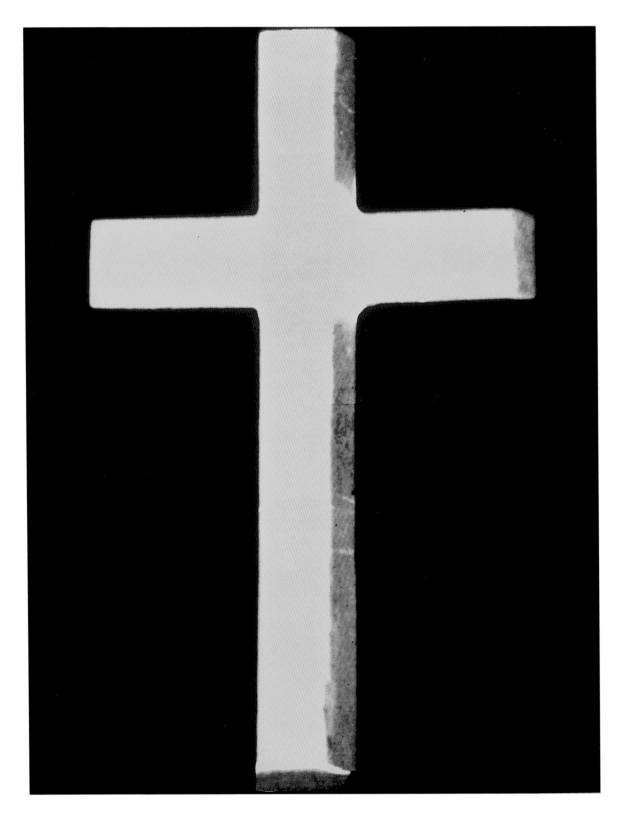

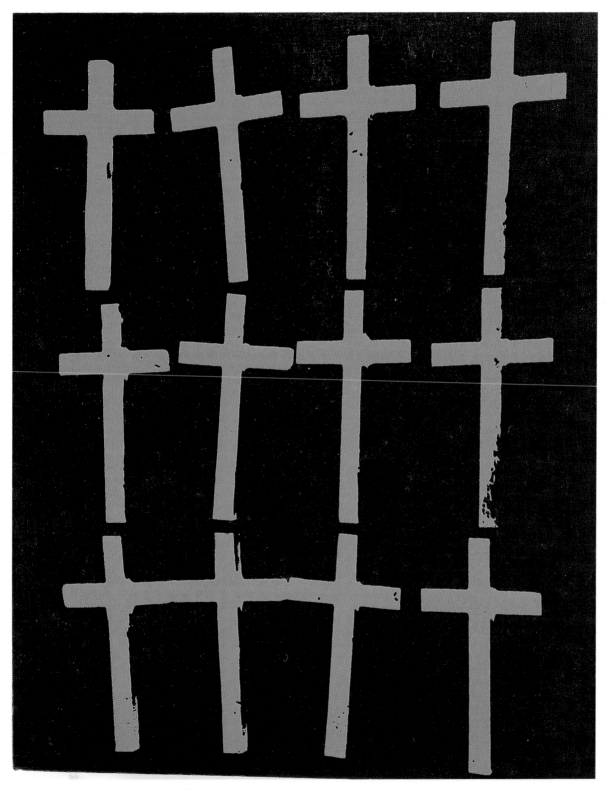

25. Andy Warhol, *Crosses* (12), 1981–82. Synthetic polymer paint and silkscreen on canvas, 20 x 16 in.

Warhol was interviewed in connection with this exhibition: the interviewer, referring to the paintings of guns and knives, asked Warhol about the much-publicized attempt on his life in 1968: "Isn't getting shot a shocking experience?" Warhol deflected the question, replying, "Think of all the people getting stabbed on the street right now." The interviewer continued, "How do you see yourself twenty years from now?" to which Warhol replied, "I really don't know, I guess I just hope to be alive."[2] Five years after the "Guns, Knives, and Crosses" exhibition Warhol died. It was during those last five years that most of his religious works were done.

In 1982, the same year as the *Cross* paintings, Warhol also did a series of prints and paintings using eggs as the motif (fig. 26). The egg has a long history of symbolic associations from the prehistoric tombs in Russia and Sweden, where clay eggs are presumed to be emblems of immortality, to the Easter eggs which symbolized resurrection. Warhol's mother had followed the Byzantine Easter practice of painting eggs. Warhol's first egg designs were small works on paper, given to friends and clients as Easter gifts, but he also did large silkscreened canvases in a range of brilliant colors that correspond to those available in the Paas egg dyeing kits to be found in supermarkets at Eastertime. These paintings have stunning designs with the figure and ground locked together in a breathtaking balance. The colored eggs seem both to tumble freely against the black ground and to be integrated into space, suspended but immovable. They can be seen as exuberant abstract designs or as a kind of doxology, a cry of praise.

Two years later Warhol did a series of prints titled *Details of Renaissance Paintings*, based on religious paintings by the Renaissance masters. These *Detail* paintings are Warhol's selection from the data bank of art history, showing the revisionist thrust of postmodernist twentieth-century art, as Robert Rosenblum has observed.[3] Other artists were appropriating and recreating the great art of the past, often with an ironic or sardonic twist. Warhol's manipulation of the Renaissance paintings was through radical cropping, so that the subject matter of the original is all but unreadable. In addition, the subtle and darker palette of the Renaissance masters is replaced by a cacophony of Day-Glo colors that assault and delight the eyes.

Warhol's *Leonardo da Vinci, The Annunciation, 1472* (fig. 28) is based on a very early painting by Leonardo (fig. 27), now in the Uffizi, which shows the angel Gabriel kneeling on a grassy, flower-bestrewn lawn before the Virgin, who sits at an elaborate and obtrusive lectern, which clearly had fascinated Leonardo. Warhol has eliminated the foreground and the figures and focuses instead on the landscape with its violet triangular mountain, which joins the expressive hands of Gabriel and the Virgin. The angel's hand is erect and urgent, and the Virgin's fingers are spread responsively as her hand rests on the corner of the lectern. To those who identify the biblical source, the print may express the core of the story in a kind of sign language, the communication from the heavenly messenger to the earthly vessel at the moment of the Incarnation. To others the hands can be seen as graceful gestures signifying stimulus and response; they are set against a landscape of striking beauty. In Leonardo's paintings his originally subtle colors are now

26. Andy Warhol, *Eggs*, 1982.
Synthetic polymer paint and
silkscreen on canvas, 90 x 70 in.

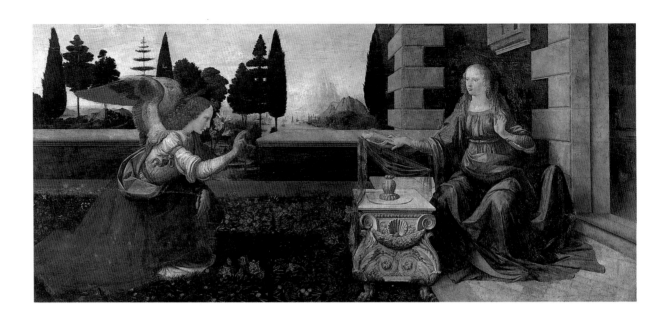

27. Leonardo da Vinci, *The Annunciation*, 1472.

muted and darkened by layers of varnish and dirt; Warhol used brilliant, high-keyed, and non-naturalistic colors and printed them in four different color combinations, all of them stunningly original.

The print entitled *Piero della Francesca, Madonna del Duca da Montefeltro, circa 1472* (fig. 30) must perplex those who first view this strangely compelling work. Instead of seeing a Madonna, we see a Renaissance architectural niche that luminously embraces a seashell from the tip of which hangs suspended what seems a surrealist addition, an ostrich egg. The shell suggests a womb shape, within which the ovoid form of the large egg floats before us.

Warhol appropriated only the upper zone of Piero della Francesca's painting. In Piero's majestic scene (fig. 29) the Virgin is encompassed by a half-circle of solemn saints, her head reiterating the shape of the egg above. There was, in fact, such an egg in an Umbrian church known to Piero. In the altarpiece it is a symbol of fertility and an evidence of the wonders of creation. An extraordinary personage in the silent assemblage about the Virgin is the donor, the duke of Montefeltro, who kneels in his conspicuously shiny armor; his warrior's hands, held in the attitude of prayer, lead directly to the Christ child's slumberous nude body. All of this scenario is ignored by Warhol (fig. 30), who, by isolating the niche and the shell, brings into mystical prominence the ostrich egg.

Warhol also appropriated a slice of Paolo Uccello's *St. George and the Dragon* (fig. 31), painted in 1460, wherein Uccello depicts something of the magical world of the fairy tale with its make-believe dragon and paper-mache cavern. Warhol's translation (fig. 32) of the princess and the dragon's spiky, spotted wings and corkscrew tail suggests a segment of a comic strip rather than an episode from the legendary life of St. George. Is Warhol showing us that the feats of heroism and derring-do that make up the lives of the

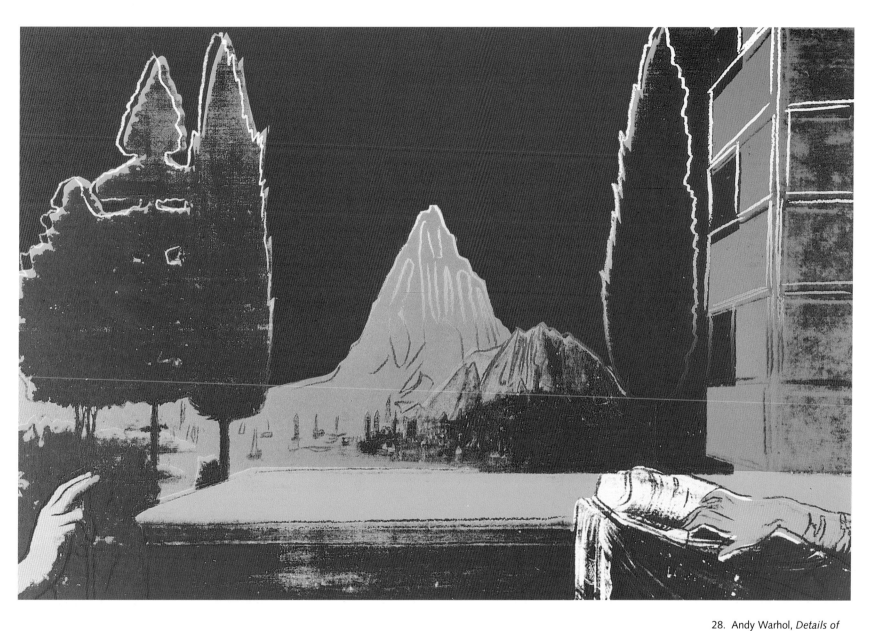

28. Andy Warhol, *Details of Renaissance Paintings (Leonardo da Vinci, The Annunciation, 1472)*, 1984. Screenprint on D'Arches paper, 32 x 44 in.

29. Piero della Francesca,
Madonna del Duca Federico,
ca. 1472.

saints are now to be found in the comics, that the exploits of Superman and Dick Tracy are this century's mythology?

Warhol's *St. Apollonia* is another lithograph based on a religious painting. In this case, it is Warhol's fidelity to the original painting in the National Gallery in Washington by Piero della Francesca (or an artist in his circle) (fig. 33) that is noteworthy. The frontal iconic image of the saint is replicated with little marginal cropping. Even the cracks in the paint surface are delineated in Warhol's print (fig. 34). St. Apollonia, the patron saint of dentists, who is said to have had her teeth torn out in an assault intended to make her recant, stands serenely before us holding a pincers with one of her molars in its grip. Warhol has flattened somewhat the rounded forms of Piero with the result that his *St. Apollonia* has the two-dimensional clarity and assertiveness of a playing-card queen.

Among Warhol's work of the eighties is a drawing catalogued as a *Mother and Child*. It has none of the signs or symbols identifying it as a Virgin and Child, but it is one of a series Warhol projected of the

30. Andy Warhol, *Details of Renaissance Paintings (Piero della Francesca, Madonna del Duca da Montefeltro,* ca. 1472), 1984. Screenprint on D'Arches paper, 32 x 44 in.

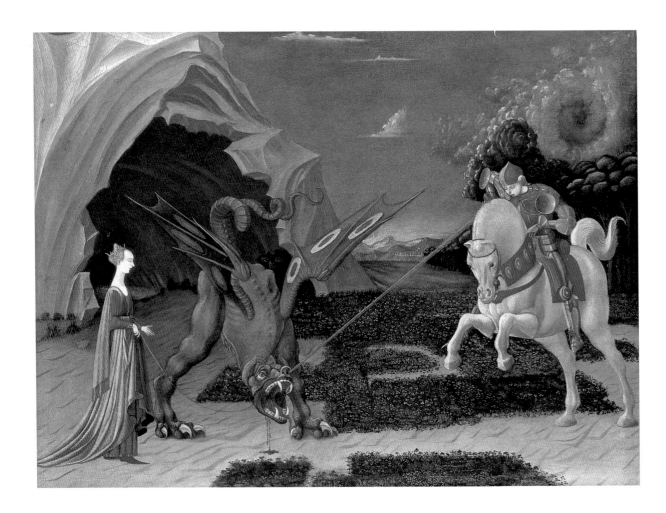

31. Paolo Uccello, *St. George and the Dragon*, 1460.

modern Mother and Child (fig. 35). The contours of the figures have an immediacy unusual in Warhol's work. It is unusual also in the way the figures fill the page, indeed seem to expand their limited space. The expression of absorption as the mother looks down upon her suckling baby and the dreamy gaze of the sensually satisfied child are arresting.

 The drawing of the *Mother and Child* is a twentieth-century version of the Madonna Lactans, or the Mother with the nursing Christ child. Some of these earlier paintings show the Christ child looking toward the viewer as he nurses at the Madonna's breast[4] as Warhol's child does. Warhol probably had seen such paintings, but the immediate idea for the series was recorded in his diaries: "Went into a bookshop [in Paris] and I finally came across the next idea I really want to work on—mothers with babies sucking on their tits. . . . Its just so erotic, I think its a good subject."[5] Warhol's only works that have something of the intimacy of this drawing are those of young amorous male couples. Warhol's gay sensibility was able to enter into empathy with the heterosexual Mother's orientation toward her son.

32. Andy Warhol, *Details of Renaissance Paintings (Paolo Uccello, St. George and the Dragon*, 1460). Synthetic polymer paint and silkscreen on canvas, 48 x 72 in.

33. Workshop of Piero della Francesca, *Saint Apollonia*, before 1470. Tempera on panel, 15¼ x 11 in.

Warhol liked children. Christopher Makos said that he "needed to have contact with at least four or five kids a day. He loved smart ones as much as beautiful ones, but if they were dumb, he'd say, 'Oh, God, not another one.' . . . He felt more comfortable with children than he did with art collectors and serious fans."[6]

Warhol turned again to a Renaissance painting for his first large painting with a religious theme; he used Raphael's famous *Sistine Madonna* (fig. 37) as the basis for his playful *Raphael I-6.99* (fig. 36). It looks back to Warhol's Pop paintings with its imaginative manipulation of the image and the jolting addition of a commercial price tag. But it looks forward to the late *Last Supper* paintings in its large scale and draftsmanship.

Rather than using a photograph as the basis of the painting, Warhol used an illustration from a late-nineteenth-century encyclopedia on art which had an outline drawing of Raphael's *Sistine Madonna* (fig. 38). Comparing Warhol's wiry, black contour lines with those of his source, it is surprising how closely he followed that illustration line for line. The differences are the omissions: the glory of cherubim, and the lower part of Raphael's painting showing Pope Sixtus II's elaborate cope and his papal tiara (the painting's title refers to him), which rests on a balustrade that supports a pair of much-reproduced plump cherubs.

In Warhol's painting, however, it is the bright red-and-yellow price tag that leaps out at the viewer obtrusively. It hangs behind the head of Pope Sixtus, but in front of the arm of the Christ child. All of the carefully orchestrated relationships of Raphael's figures, which are located in the space behind a large window enframing his vision of the Virgin and Child descending toward our realm, are played with by Warhol. We do not see the drapery rod at the top or the window sill below Raphael's misty, cloud-filled, cherub-filled setting: instead we experience the exuberant play of Warhol's wiry line and the presence of a second image, a pink-pink Christ child, illogically placed horizontally below.

The obtrusive, oval $6.99 price tag appears again in one of Warhol's largest paintings based on Leonardo's *Last Supper*. How can one interpret the presence of what seems a crassly commercial symbol in these two religious paintings? It is the commercial marketing world that has reproduced these two religious masterpieces in cheapened and distorted copies, making them ubiquitous and finally boring. Is Warhol's price tag a jolting reminder of this? Another interpretation would link these price tags with Warhol's paintings of dollar bills, a series done in 1962, and the *Dollar Sign* paintings, a series done in 1981. Though a wealthy man when the Leonardo and Raphael paintings were done, Warhol was extremely money conscious and never lost the anxiety about money that the grinding poverty of the early years in his immigrant home had instilled.

A third interpretation might be that the price tags are Pop emblems, brilliant in color and large in size, added to two famous paintings that Warhol has transposed into Pop images, draining them of any religious content and equating them with the world of buying and selling. There is, however, a spirited

The Religious Art of Andy Warhol

34. Andy Warhol, *Details of Renaissance Paintings (Piero della Francesca, Saint Apollonia)*. Screenprint on Essex offset Kid Finish paper, 30 x 22 in.

35. Andy Warhol, *Modern Madonna,* ca. 1980–81. Pencil on paper, 40½ x 31¼ in.

playfulness to Warhol's painting that does not seem irreverent either to Raphael's famous painting or to its religious content. Perhaps there are elements of all of these interpretations which constitute the kaleidoscope of meanings of this painting.

Warhol's most enigmatic paintings of the last decade before his death are the *Shadows* series of 1978 (fig. 39). In January 1979 Phillipa de Menil and Heiner Friedrich acquired from Warhol 102 paintings entitled *Shadows,*[7] and they were exhibited in a Soho gallery. The main room was not large enough for the 102 paintings, but 83 were hung at eye level along three sides of the gallery. Warhol, who hung the paintings with his "kids" (as he referred to his assistants), designated the presentation as "one painting with 83 parts." The exhibition catalogue includes his comment:

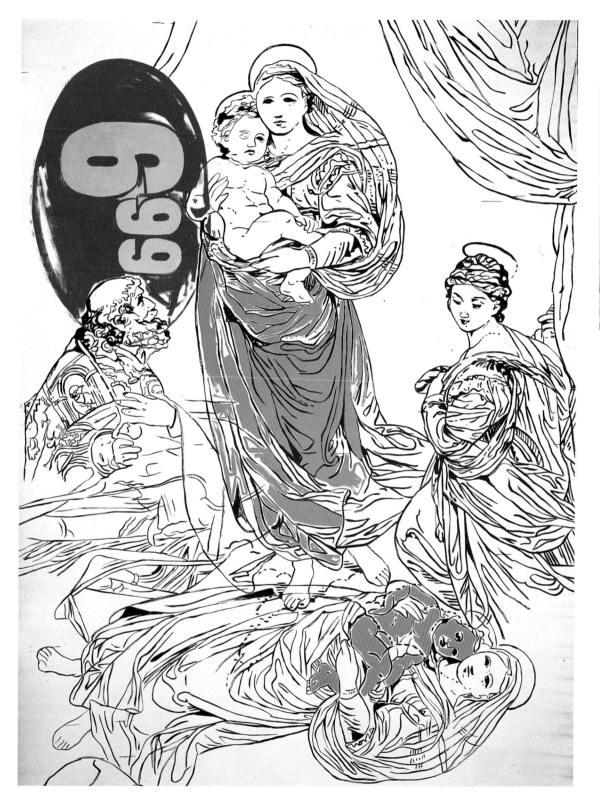

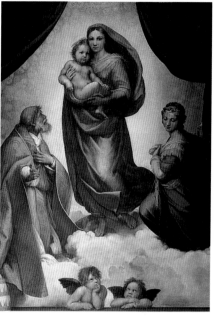

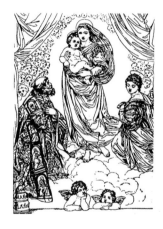

36. Andy Warhol, *Raphael I–6.99*, 1985. Synthetic polymer paint and silkscreen on canvas, 90 x 70 in.

37. Raphael, *The Sistine Madonna*.

38. Raphael, *The Sistine Madonna*. From a nineteenth-century encyclopedia on art.

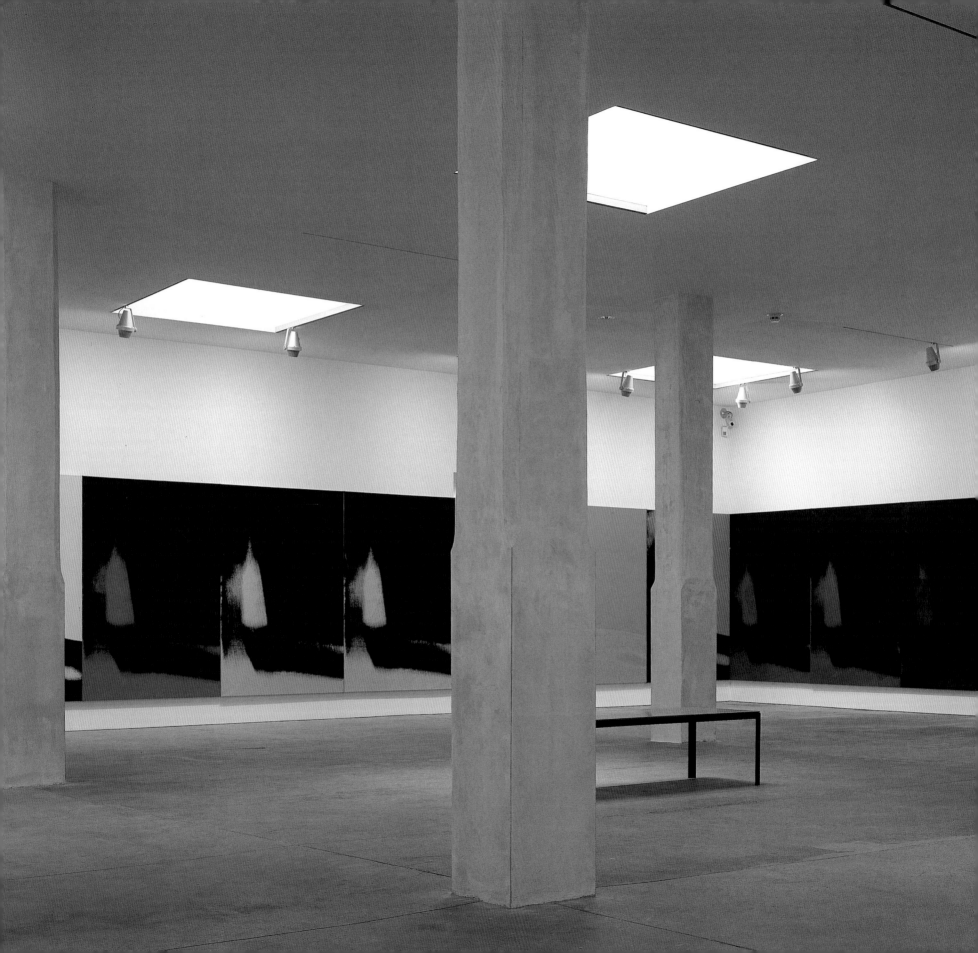

39. Overleaf: Andy Warhol, *Shadows,* 1978.

40. Left: Andy Warhol, *Shadows,* 1978. Synthetic polymer paint and silkscreen on canvas, 76 x 52 in.

41. Andy Warhol, *Shadows*,
1978. Synthetic polymer paint
and silkscreen on canvas,
78 x 200 in.

Each part is 52 inches by 76 inches and they are all sort of the same except for the colors. I call them *Shadows* because they are based on a photo of a shadow in my office. It's a silkscreen that I mop over with paint. I started working on them a few years ago. I work seven days a week. . . . But I get the most done on weekends because during the week people keep coming by to talk. . . . I had the paintings hung at eye level. But the kids helped me. . . . The gallery looked great. It's a simple, clean space."[8]

When hung edge to edge in a large gallery, the paintings flow rhythmically around the four walls, encompassing the viewer with brilliant flashes of color in the flame-shaped repeated image, which is set against a richly black background (fig. 40). A second image, an attenuated triangle with a blurred left edge and two sloping vertical areas below, is repeated many times, usually in black against brilliant color—turquoise, apricot, scarlet, a sharp chartreuse, and a soft first-spring green.

The *Shadow* images are based on photographs taken by Ronnie Cutrone, who reported:

I just got matte board and pieces of cardboard, arranged them and tone them up and photograph them. And then, we get the photographs back, pick the photographs we like the best, usually more than we're actually going to do so we have a choice. Then they're

matted into acetates or positives and blown up. And then we just lay it down on white paper and see how it works blown up—if it holds up, or if it breaks down. Then in the case of paintings, it would be mopped out on the canvas . . . contrary to popular belief, it's the [background] painted first . . . the photograph is always intact and it lies on top of the painting.[9]

The *Shadows* unfold on walls, creating a nighttime world, a shifting kaleidoscope of brilliant, life-full color set against the black shadows of a final darkness.

Another series of *Shadows,* vast horizontal landscape-like expanses of velvet black forms enveloped by phosphorescent white or golden tones, speaks another language, the light penetrating the darkness like clouds concealing, then revealing. The viewer experiences "the moment of grandeur . . . when you're overwhelmed," as Ronnie Cutrone, who was working with Warhol on the *Shadows,* said.[10]

In *Shadows,* the black zone at the left blurs off into the glowing golden beige expanse at the right (fig. 41). The silkscreen used for the image is so merged with the hand-painted ground that the screen has been used almost as if it were another brush. Warhol's virtuosity with the silkscreen medium led him further and further into abstraction, and with the creation of these majestic and numinous *Shadows* he was close to the style and content of the abstract expressionists, particularly Barnett Newman and Mark Rothko, both of whom aspired to creating paintings that expressed the Sublime. Warhol's large *Shadow* paintings have the grandeur of conception and the delicacy of the abstract expressionists' most profound works. They belong in the company of Newman's *Stations of the Cross* and Mark Rothko's paintings for the Rothko Chapel in Houston, and Cleve Gray's fourteen *Threnody* paintings in Purchase, New York.

When one studies *Shadows,* the eschatological question of mortality and the end of time arises. For the artist Julian Schnabel, "these paintings hover as the shadow of life's edge."

42. Andy Warhol, *Mother and Child.* Ink blot and water-color on paper, 9³/₄ x 8³/₄ in.

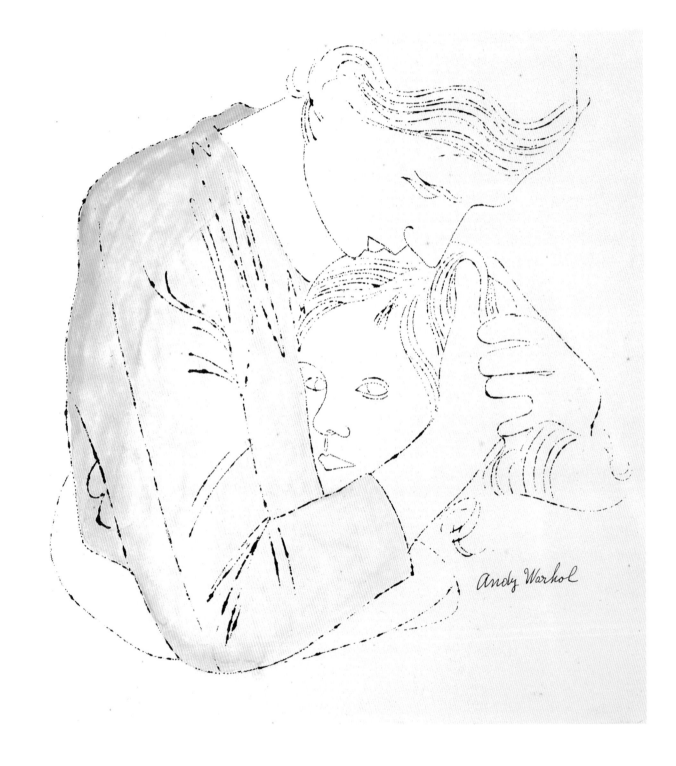

3: Memento Mori: Death and the Artist

Warhol, who was born on August 6, the day the atom bomb was dropped, had the notion that almost by destiny he had been fated to be obsessed with ultimate destruction and death. —Charles Stuckey

The specter of death haunted Andy Warhol. It was the theme of a series of his paintings even before the nearly fatal shooting by Valerie Solanas. During the five hours of surgery following her attack, Warhol's heart stopped beating, but the medical team brought him back quite literally from the grip of death.

Warhol later connected the *Death and Disaster* paintings with Valerie Solanas's assassination attempt. He recounted that it was Henry Geldzahler "who gave me the idea to start the *Death and Disaster* series. We were having lunch one day in the summer at Serendipity . . . and he laid the *Daily News* out on the table. The headline was '129 Die in Jet.' And that's what started me on the Death series—the *Car Crashes,* the *Disasters,* the *Electric Chairs.*" The first of the series was based on the *Daily News* front page. Warhol added in parentheses: "Whenever I look back at that front page, I'm struck by the date—June 4, 1962. Six years to the date later, my own disaster was the front-page headline: 'Artist Shot.'"[1] It was on June 4th, 1968, that Valerie Solanas shot Warhol.

But death was a recurrent theme of Warhol's art from 1960 on, some years before the assassination attempt. The traumatic experience of his father's illness and death, and his mother's emergency surgery for cancer and her complicated convalescence, along with his own childhood confinement as a result of "three mental breakdowns," left Warhol with a pervasive fear of death—and disaster. An early drawing, *Mother and Child* (ca. 1948) (fig. 42), shows an Andy-like child in the tender and protective embrace of his mother. The child clings to her but looks warily and fearfully at us.

An incident in Warhol's Carnegie Institute pictorial design class has resonances with his later dealing with death. The class assignment was to illustrate the dramatic climax of a Willa Cather story in which a suicide is described: the professor designated a nearby bridge as the site of the fictive suicide, and most of the class pictured the bridge as the setting for a descriptive drawing of the event. Warhol's rendering of

the assignment was a "striking red blob of tempera paint. Standing before it the professor observed: 'It could be catsup,' to which Warhol replied in a nearly inaudible voice, 'It's supposed to be blood.'"[2] Warhol had made an imaginative leap from the assigned illustration to a gruesome symbol for the terrible finality of the suicide.

The Death and Disaster Series

The year he began the *Death and Disaster* series was also the year of the exhibition of Warhol's quintessentially Pop works of art, the *Campbell's Soup Cans.* Throughout his career Warhol worked simultaneously on different series and projects, but in the early sixties the exuberance of his Pop works contrasted dramatically with his macabre series on violent death. Henry Geldzahler recalled midnight phone calls from Andy in the mid-sixties when he said he was afraid of dying if he went to sleep.[3] "He wouldn't fall asleep until dawn cracked because sleep equals death and night is fearsome, and if you fall asleep at night, you're not quite sure about waking up again."[4]

The series was based on photographs of actual car crashes showing demolished ambulances and sports cars with crumpled and sightless bodies spilled onto the highway in pools of their own blood. The paintings are jolting in their impact. The immediacy of Warhol's *Disaster* paintings contrasts with Picasso's *Guernica* (fig. 43), which also depicts violent deaths. Picasso imaged the death and destruction of war by depicting bodies flattened and wrenchingly distorted: a mother who holds her dead child in her arms, a dying warrior who clutches a blossom and a broken sword in one hand, a shrieking woman jumping from a burning building. These anguished figures become tragedians in a Greek drama of mythic scope: they embody suffering, and they accuse the destructive forces deep in the human heart. In contrast to the epic dimensions of *Guernica,* Warhol's *Disasters* have the macabre immediacy and pathos of random deaths of ordinary people occurring in the routines of their everyday lives.

By the use of enlarged photographs of the actual event, Warhol makes the viewer a witness of the gruesome and pathetic deaths, causing a pang of dread and a recognition of the fearful fragility of life. The photographs were culled from the tabloids, *Life* magazine, and the popular press. Between 1962 and 1967 Warhol did silkscreened paintings of suicides, car crashes, the atomic bomb, the electric chair, race riots, and death by poisoning and by earthquake. These paintings range from the gruesome *Car Crash* paintings to the *Electric Chair* series, which is a meditation on mortality and death.

While Warhol was working on the *Death and Disaster* series, he was interviewed by Gene Swenson; he told about coming out of a movie "and somebody threw a cherry bomb right in front of us, in this big crowd. And there was blood. I saw blood on people and all over. I felt like I was bleeding all over. I saw in

the paper last week that there were more people throwing them—it's just part of the scene—people hurting people. My show in Paris is going to be called 'Death in America.'"[5]

The *Death and Disaster* series is a kind of twentieth-century dance of death. In Holbein's sixteenth-century *Dance of Death*, all manner of men and women, cardinals and kings are depicted in their daily round when the sinister, skeletal figure of death grips them suddenly. In the twentieth century, the car accidents and crimes that are just "part of the scene," as Warhol said, are our daily dance of death.

Other paintings in the series speak a different language. They too are *memento mori*—remember that you must die—but these works are elegiac, or meditative, in mood. *Suicide* (Fallen Body) (fig. 44) is based on a photograph by Robert C. Wiles from *Life;* it shows a twenty-three-year-old model who jumped from the observation deck of the Empire State Building to her death. When one first views the ten-by-six-foot painting, it is the abstract black pattern with its undulant highlighted forms that absorbs the viewer's attention; then the multiple repeated images become clear. The model is serene and whole in death, her body cradled on the indented top of a car, her face tranquil, her body relaxed, her white-gloved hand touching her pearls. As the eyes move down the painting, the images become less clear and overlap, leaving peripheral blank areas. Finally, in the last register, five images are overprinted, accelerating the rhythm and making the face and body of the pretty model increasingly unreadable, until in the lower right she is lost in the pattern of dark and light shapes. The tragic suicide has metamorphized into a sleeping beauty. But the security of her sleep is violated by the jolting reality of gawking spectators, her tangled stockings, and a crumpled car roof.

Warhol said of the suicides and car-crash victims, "It's not that I feel sorry for them, it's just that people go by and it doesn't matter to them that someone unknown was killed . . . I still care about people, but it would be so much easier not to care."[6] As Walter Hopps said, there are a "range, power and empathy underlying Warhol's transformation of the commonplace catastrophes in the *Death and Disaster* series," and he added, "one can sense in this art an underlying compassion that transcends Warhol's public affect of studied neutrality."[7]

Warhol did a series of *Electric Chair* paintings—some in 1963, others in 1965 and 1967. All are based on the same photograph, thought to be of the execution chamber in Sing Sing state penitentiary in New

43. Pablo Picasso, *Guernica,* 1937.

44. Andy Warhol, *Suicide*, 1963. Synthetic polymer paint and silkscreen on canvas, 111½ x 80⅓ in.

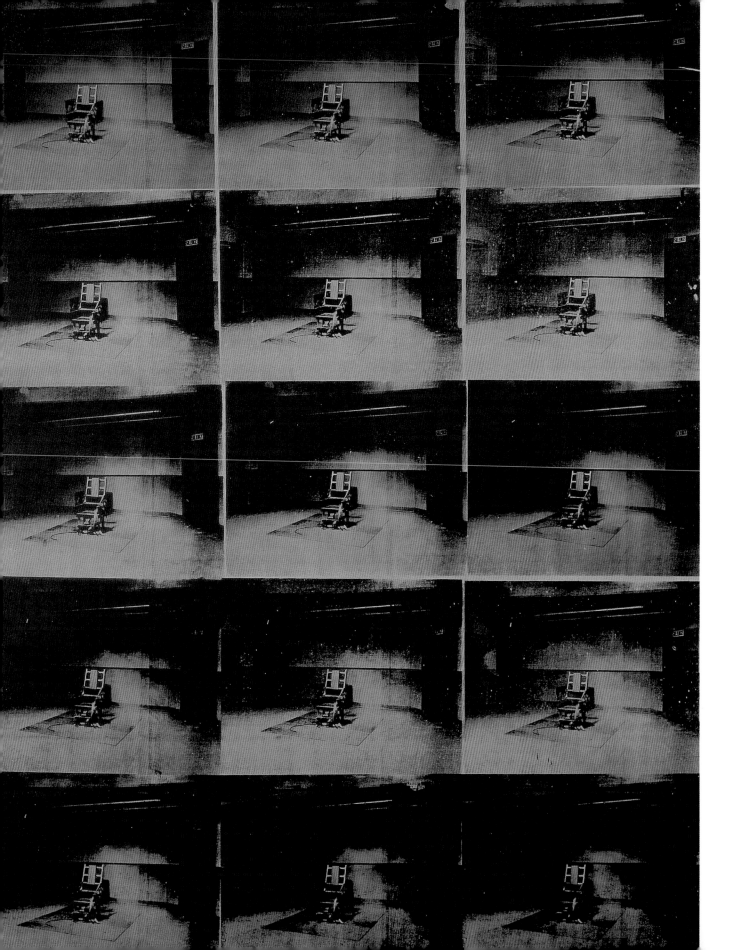

45. Andy Warhol, *Lavender Disaster,* 1963. Synthetic polymer paint and silkscreen on canvas, 106 x 82 in.

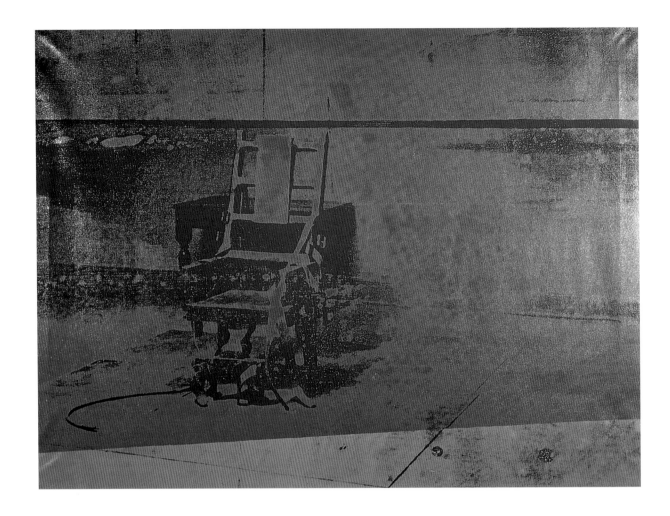

46. Andy Warhol, *Big Electric Chair*, 1967. Synthetic polymer paint and silkscreen on canvas, 54 x 74 in.

York. It was there that the state's last two executions were carried out with much publicity in 1963, the year of Warhol's first paintings. The photograph shows a room empty except for the electric chair, which is almost at its center, with light falling upon the chair. The single other visible object is a sign at the right proclaiming "Silence." In the *Lavender Disaster* (fig. 45) the repetition of this image is symmetrical, with three images across the width of the painting and five laterally. A spectral light illumines the right-hand image, where the black shadows, which increasingly encroach upon the light, now encompass most of the room; the sign requesting silence is no longer visible. But the darkness of the lower right register seems less a negation of the image and its meaning than a coda to, and a meditation on, death.

Four years later, in 1967, Warhol returned to the electric chair theme, producing a group of large single images of the chair (fig. 46). By printing color on color, rather than black over color, he created a vibrancy of close-toned, brilliant color. The electric chair seems to dissolve and recompose itself and to radiate and reflect colored light. The chair is transformed from a grotesque instrument of death into a

numinous object, suggesting transcendence, much as the cross, which was used for a particularly cruel kind of execution, is seen in Christian art as a symbol pointing to salvation.

The Skull Paintings

Among the Polaroid photographs Warhol took in the seventies is a striking series of Warhol himself with a skull (fig. 47). In one of these, the vacuous, empty eye sockets of the skull make all the more riveting Warhol's eyes and his complex expression. Warhol's usually "albino-chalk skin" is given a ruddy glow by makeup. Though his glance does not focus toward the spectator, his parted lips, with perhaps the beginning of a smile, suggest an accessibility that is markedly unusual in his self-portraits. The grinning skull on his shoulder (supported by a hand) seems in conversation with the artist.

When Warhol was fifty, he did a self-portrait (fig. 48) based on a photo in this series. Warhol painted freely on the canvas—yellow, blue, red, and white—and then printed his own features and those of the skull in black outline. Both Warhol and the skull appear more spectral in the painting; the artist's face seems to disintegrate in front of our eyes. Warhol did two other related self-portraits in 1978, one with bony, dark hands about his throat, the other with the skull on his shoulder, but without the supporting hand.

The skull as a *memento mori* appears in seventeenth-century portraits such as Frans Hals's *Young Man Holding a Skull* (fig. 49) as well as in depictions of penitent or contemplative saints. Such paintings, with the portrait juxtaposed to a skull, are called *vanitas* paintings and are a reminder of the transience of life and the certainty of death. Hals's dashing young man is in movement; his gesturing hand, quick glance, and open lips bring him into conversation with us. He holds the skull toward us, its bony cranium echoing the turn of the young cavalier's head; the rakish feather on his hat droops forward pointing toward the skull. But the young cavalier is all extrovert, and the painting points up by contrast the impenetrable remoteness and isolation of the twentieth-century artist and what Trevor Fairbrother called Warhol's "continual fingering of mortality."[8] In 1976 Warhol did a series of paintings of *Skulls* (fig. 50). The resurgence of skull imagery accompanied punk culture and is related to anxiety over the spread of AIDS as well as the escalating threats of nuclear war and ecological disasters.

Warhol found the skull he used in this series in a Paris flea market in the mid-seventies. He later asked Fred Hughes, his business manager, and Ronnie Cutrone, his studio assistant, what they thought about his using it as a subject. Hughes recalled Picasso's and Zurbaran's skull paintings, and Ronnie Cutrone said, it would be "like doing the portrait of everybody in the world."[9] During the seventies, Warhol did an extraordinary number of portraits, not only of celebrities and friends but also of many dif-

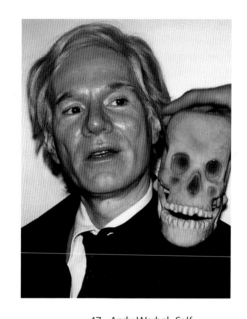

47. Andy Warhol, *Self-Portrait*, 1977. Polaroid photograph, 4½ x 4⅝ in.

48. Andy Warhol, *Self-Portrait with Skull*, 1978. Synthetic polymer paint and silkscreen on canvas, 16 x 13 in.

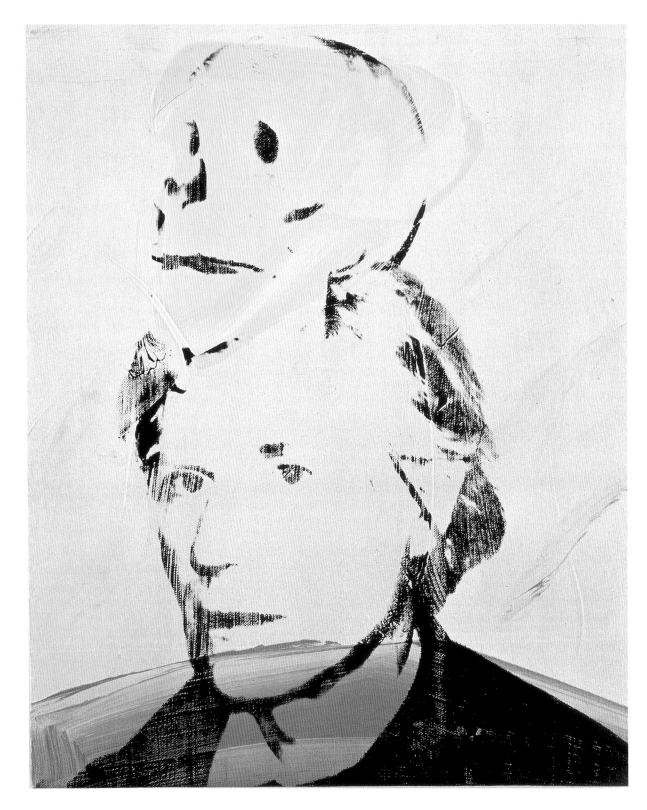

The Religious Art of Andy Warhol

ferent types of people. These portraits were shown in a large exhibition in New York at the Whitney Museum of American Art in 1979. Cutrone's remark has a wry aptness, for the *Skulls* were done concurrently with the who's who of his commissioned portraits.

Ronnie Cutrone was instructed to take photographs of the flea market skull. In reflecting on his work with Warhol, Cutrone said in an interview, "sometimes I don't understand what he means, sometimes I do. [For the skull photographs] I didn't know at first what he wanted, I just shot. I knew what he wanted but not as an image. So I took the photos, and then we went over the contact sheets and decided it did look good and blew them up."[10] Patrick Smith asked Cutrone what Warhol's idea was in doing the *Skulls,* and he replied, "I don't know why. We never talked about that."

Cutrone testified to the intuitive nature of the process of doing the photography, then the painted background, and then working with the printer's image, saying "there are moments of grandeur that appear . . . it's just not audible. And that's nice because when you work closely with somebody, you know how you feel about what you're doing. Sometimes words just aren't necessary."[11] Cutrone also insisted that the general assumption that other people did Warhol's paintings was untrue: "I don't really touch his paintings at all. . . . We work on it together, we talk about it. . . . But nobody really touches the work except Andy."[12]

Eight of the large *Skull* paintings hang in two ranges and cover an entire wall at the Andy Warhol Museum, and two gigantic paintings eleven by twelve feet are on the side walls. The colors of the *Skulls* are literally shocking in their brilliance, originality, and unexpected juxtapositions: a pink skull against a green, turquoise, and apricot background; a beige skull which throws a black and scarlet shadow against an olive green and peacock blue ground; a gentian blue skull with a jonquil yellow shadow and black and gunmetal ground. The placing of the skull varies as do the shadow shapes, and the expression of the grinning skull differs in each painting even though it was printed by the same screen throughout. The *Skull* paintings are not only striking in size and color, but the luscious brushwork and color give this macabre subject a contradictory lyricism and gripping beauty.

Ronnie Cutrone noted that the shadow of the skull looks like the head of a fetus—thus, death and life are here juxtaposed (fig. 51). Warhol subtly emphasized the fetal-shaped black shadow by placing it against a second colored shadow, which encompasses it and sets it off against the surface on which the skull is located. The beginnings of life—the fetus with its bulging head and tiny upturned nose—is here contrasted with the huge grinning skull with black, empty eye sockets. Warhol remarked on the transience of life on more than one occasion. Particularly apt in regard to the Skulls is this statement:

Few people have seen my films or paintings, but perhaps those few will become more aware of living by being made to think about themselves. People need to be made aware

49. Frans Hals, *Young Man Holding a Skull*, seventeenth century.

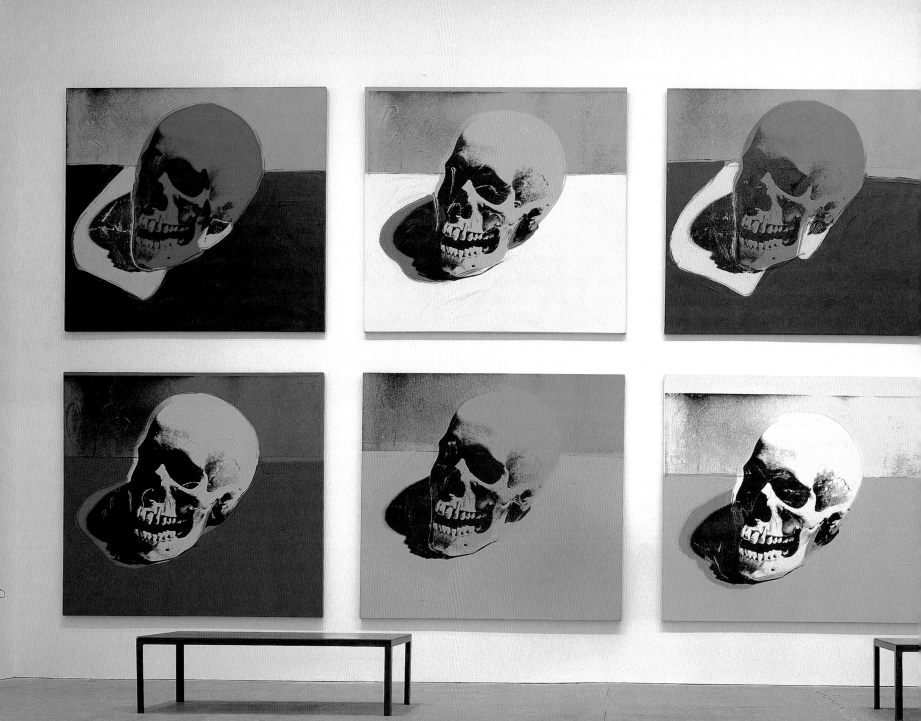

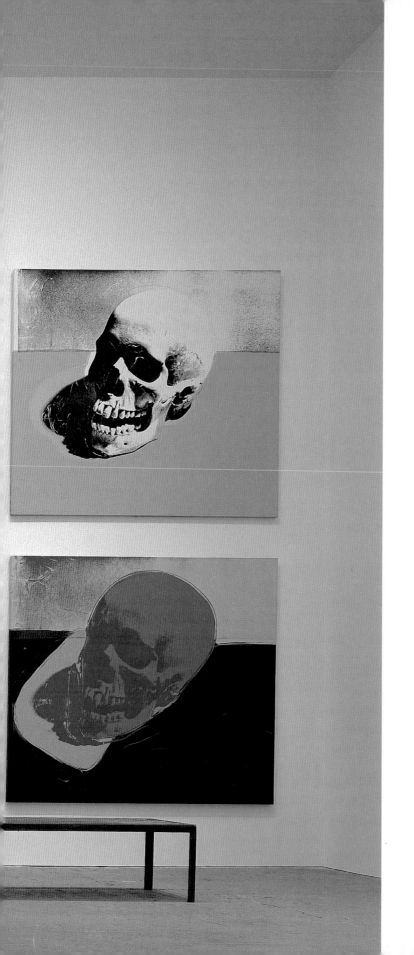

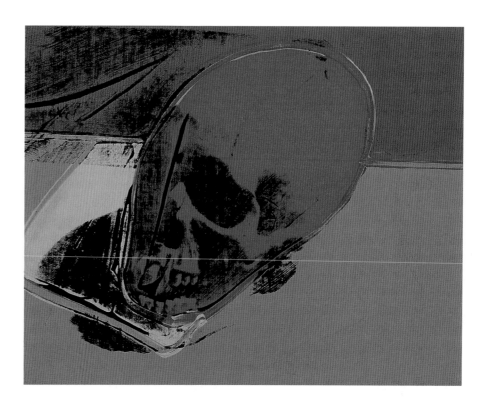

50. Overleaf: Andy Warhol, *Skulls*, 1976.

51. Above: Andy Warhol, *Skull*, 1976. Synthetic polymer paint and silkscreen on canvas, 15 x 19 in.

52. Andy Warhol, *Skeletons,* 1987. Machine-sewn photographs, 9½ x 7½ in.

of the need to work at learning how to live because life is so quick and sometimes it goes away too quickly.[13]

Thus, *Memento Mori!*

The *memento mori* theme recurred in a group of Warhol's last works. In this case it is full skeletons that inhabit photographic prints (fig. 52). The day after Warhol's death the Swiss art journal *Parkett* received a package from the Factory that had been mailed before Warhol went into the hospital. Warhol had agreed to make a limited edition print for 120 deluxe copies of the journal. The print was to be about something Swiss, and the editors had sent him materials for typically Swiss images: pictures of cuckoo clocks, postcards of the Matterhorn, and packages of Toblerone chocolates. Instead of receiving prints based on one of these, the package from the Factory contained a photo edition of 120 numbered and signed copies of four stitched-together photographs of skeletons. The dynamism and beauty of the *Skull* paintings contrast in mood and in medium with these starkly lit, black-and-white skeletons, who are in search, it seems, of something—their past fleshly selves, or an identity for their anonymous gropings?

Coda

In what sense are the paintings discussed in this chapter "religious"? The *Skull* paintings are related to a long tradition in art and in Christian iconography. Jesus was crucified at Golgotha, "the place of the skull," and those works of art which picture the crucifixion often have a skull conspicuously located at the foot of the cross. This skull has a special identity: it is the skull of Adam, who was buried, legend tells, at the very spot where the cross of Jesus was erected. Warhol's anonymous Parisian skull, must have had some resonances for him with the traditional teachings of the church, in addition to the profound and complex musings on mortality that are common to us all but were exacerbated in his case by his early history and his survival of the assassination attempt of Valerie Solanas.

The *Disaster* paintings deal with sudden death and reflexively involve the viewer in the question of the value and meaning of life. In the painting of the model who jumped to her death, Warhol draws us into the picture, and a careful perusal of the multiple images suggests serenity at the heart of tragedy.

In the *Electric Chair* paintings, the ugly, death-dealing instrument of execution is transformed and bathed in supernatural light. Like the cross of crucifixion, which was the object used for criminal executions but which is seen in Christian art as a symbol of salvation, the *Electric Chair* suggests transcendence.

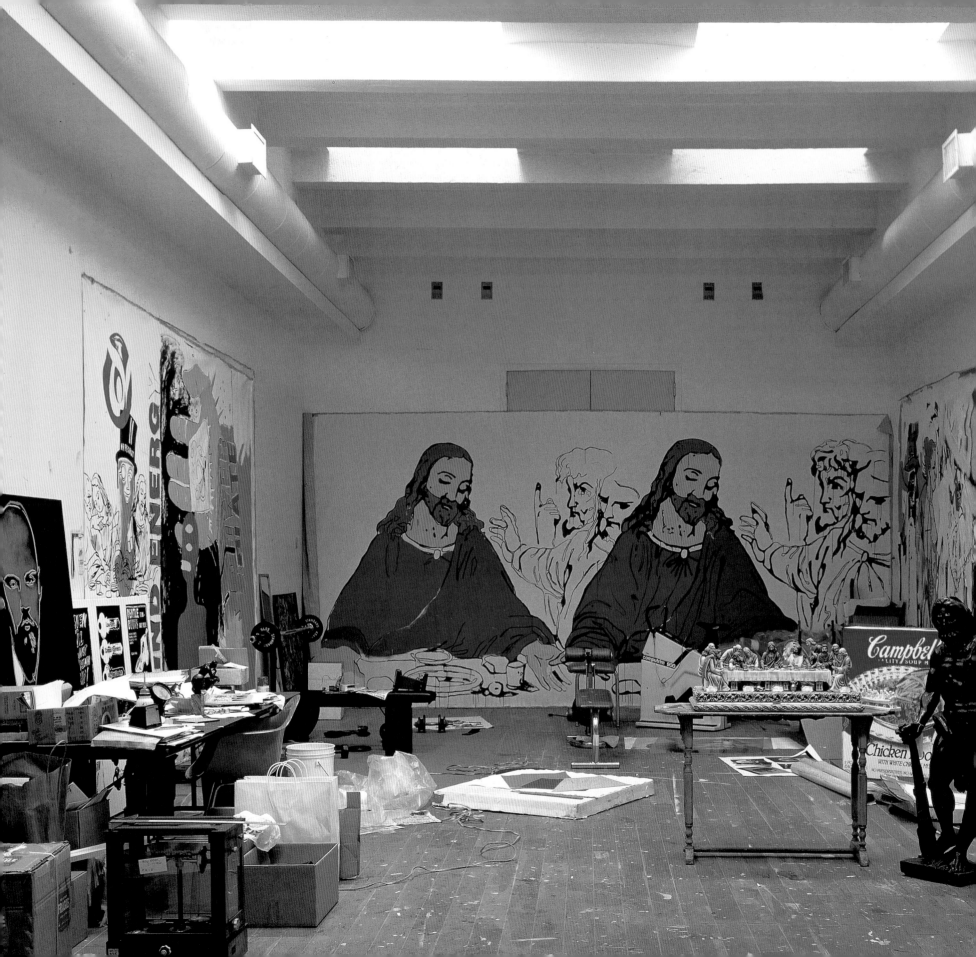

4: Leonardo's *Last Supper* Transformed

53. Overleaf: Andy Warhol's studio at the time of his death.

The Last Supper of Leonardo da Vinci formed the subject of Andy Warhol's final and arguably one of his greatest series of paintings. —Lynne Cooke

Shortly after Andy Warhol's death, his painting studio was photographed. The picture (fig. 53) shows a moment arrested in time, when the artist's presence seems almost palpable, before the inventorying and removal of the contents of his studio. What a chaotic jumble of wildly different items inhabit this room! The three walls are covered by his last paintings, and scattered to the right are pictures that Warhol bought at auctions and flea markets. In the foreground a bronze *Hercules* frowns as he leans upon his club, and behind him is one of Andy's later *Campbell's Soup* paintings. Three exercise machines, shopping bags, and cartons are strewn about the room. Dominating all of this is the large canvas tacked to the back wall with a painting of Jesus and the apostles Thomas and James twice represented. They are based on Leonardo's renowned masterpiece, the *Last Supper*, on the wall in the refectory of Santa delle Grazie in Milan.

Warhol's huge painting is strikingly different from his Pop paintings with their repertoire of familiar images. Since Warhol usually worked on series of paintings, it was certain that he had done other paintings of the Leonardo mural, though at the time of his death, they were almost unknown. Thus, my search for other related works was launched. Though an accurate count cannot be made until a complete listing of Warhol's work is finished, it is certain that there are at least twenty very large *Last Supper* paintings by Warhol, which, together with a group of smaller canvases and works on paper, constitute a kind of last will and testament of the artist. What occasioned Warhol's choice of Leonardo's *Last Supper* for what proved to be his last, and perhaps his largest—certainly his grandest—series? The image, of course, is part of popular culture, reproduced in every size and medium, including an imaginative variety of kitsch *Last Suppers* in exuberantly bad taste, some with changing colors and others painted on black velvet. Warhol,

who was an avid and eclectic collector of folk art, primitive art, and kitsch as well as traditional and contemporary art, had bought a gaudy sculpture in the Times Square novelty shops; this is seen in the photograph of his studio on the table in the foreground.

For Warhol, the Leonardo painting was not only familiar but nostalgic. His brother John Warhola said that a reproduction of the *Last Supper* hung on the walls of the kitchen where the Warhola family had their meals in their immigrant home in Pittsburgh.[1] Warhol's mother, who lived with him for twenty

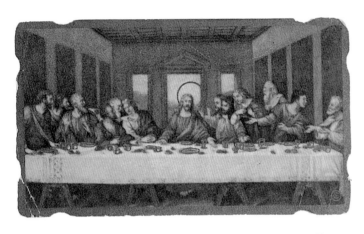

54. Julia Warhola's holy card.

years, was intensely devout. She had a small colored reproduction of Leonardo's *Last Supper* (fig. 54) in her yellowed and worn *Old Slavonic Prayer Book*, which was always at hand. On Julia Warhola's holy card, with its degraded copy of Leonardo's *Last Supper*, a huge hoop-like halo hangs akimbo about the head of Christ. Leonardo with great skill and subtlety had expressed the inner meaning of the halo—that is, the sanctity and authority of the Christ: he centered him not just in the painting but also in the room in which the mural is located on a wall in the friar's refectory. Thus, Leonardo created an illusion of the presence of Christ and the apostles in an "upper room," visible to the friars as they sat at their refectory tables in the room below. Leo Steinberg has brilliantly analyzed the strategies Leonardo used to create this illusion of the linking of the actual room with another pictured reality.[2] For the artist of the religious supply house image, however, a more obvious sign of sanctity was needed. Among other changes the copyist has transformed Leonardo's young, intensely disturbed Matthew—the third figure from the right—into a doddering, bald old man who now stands hesitant, bibbed, and helplessly looking at Christ. In copies like this Leonardo's grand mural had become ubiquitous, despoiled, and trivialized. And it had become tedious.

Warhol's two series within his *Last Supper* cycle invite us to a new viewing of the familiar image. The hand-painted canvases were begun before the silkscreened paintings and were based not on the kitsch sculptural group on the table to the right but on an illustration referred to by Warhol's assistant, Rupert Smith, in the following statement:

> Andy's last great work, the Leonardo *Last Supper*, was commissioned by Alexandre Iolas, the art dealer, early in 1986. He offered Andy the show in Milan right across the street from the real *Last Supper*. Andy worked on the project on and off for a year from photographs, but I could never get a really good photograph out of the real *Last Supper* books because the images were always so dark. In one, however, an updated Vasari type book, we found line drawings of every famous painting. Andy used that because it gave clear definition.[3] (fig. 55)

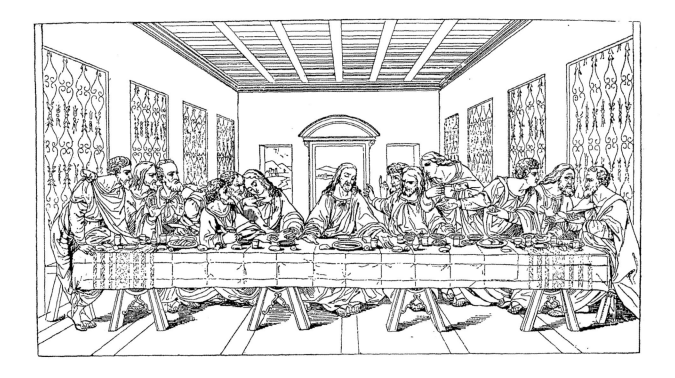

55. Leonardo da Vinci, *The Last Supper.* Outline rendering in nineteenth-century encyclopedia used as a source by Warhol.

The "Vasari type book" was an encyclopedia of paintings published originally in 1885 which had outlines of paintings "arranged alphabetically according to subject matter."[4] In the Warhol Archives in Pittsburgh there are copies of the page from the encyclopedia with the illustration of Leonardo's *Last Supper.* It was this illustration that Warhol used as the basis for the large, hand-painted canvases and his numerous drawings after Leonardo's mural.

In the encyclopedia illustration the nuances and subtleties of Leonardo's mural are reduced to traced, artless boundary lines. It is these simplified contours that Warhol appropriated for his hand-painted *Last Supper* paintings and studies. The double image of Christ, Thomas, and James which covered the back wall of Warhol's studio is based on the encyclopedia rendering and has flat, uninflected colors for the flesh, hair, and garments of the two Christ figures.

A comparison of the encyclopedia illustration with a painting from the series of Warhol's large, hand-painted *Last Suppers* (fig. 56) reveals how closely Andy followed the illustration. He himself called it his "plagiarist" style. Not only are the facial features and gestures the same, but details such as the shadows are composed of parallel hatchings that are similar. A striking difference, however, is Warhol's omission of the architectural setting and the tapestried hangings on the wall; the figures about the table thus appear monumental in size, and the table seems to be pressed forward into our space. The cropping,

The Religious Art of Andy Warhol

56. Andy Warhol, *The Last Supper,* 1986. Synthetic polymer paint on canvas, 116 x 396 in.

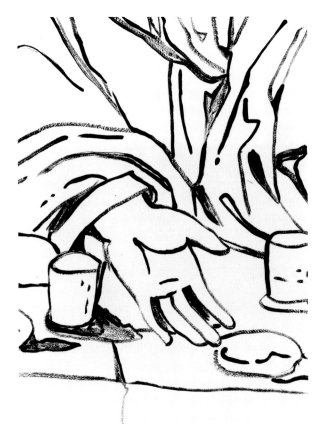

along with Warhol's uncanny sense for size, transforms the tedious, small replica in the encyclopedia into a dramatic representation of Leonardo's design, infusing into it vitality and the aura of grandeur.

The highest point, that of the head of St. Philip, is at the upper edge of the canvas, and the foreground is cut off, truncating the triangular table supports and bringing the feet of the apostles and Christ near the lower edge of the painting. This compression of the space greatly increases our sense of the volume of the figures. Their physicality, their ponderousness, confront us. The slender, ever-moving contour lines, shades of black on white canvas, give a numinous and transparent aura to the apostles and the still central figure of Christ. Yet—and it seems a contradiction—their physicality is pressed upon us. Warhol here has created his own means of expressing the humanity of Jesus and his apostles, which Leonardo had shown through his masterful illusionism.

The vigor of the hurrying lines inscribes and enfleshes these figures, who enact anew before our eyes their bewilderment at the words just spoken by Jesus, "One of you will betray me, one who is eating with me" (Mark 14:17). Warhol's painted lines are like Chinese brush strokes. The contours vary from intensely opaque blacks to the feathered delicacy of dry brush strokes. In the faces and hands of some of

59. Andy Warhol, *The Last Supper* (*Wise Potato Chips*), 1986. Synthetic polymer on canvas, 118 x 252 in.

the apostles we see a double line, which gives an unexpected transparency to their features and gestures. Their physicality becomes immaterial, as if reflected in water.

Warhol was wholly absorbed with the *Last Supper* paintings in this last year of his life, working on little else, according to Jay Shriver, his studio assistant.[5] It was Warhol's practice at this time to spend an hour or more alone in the studio at the end of the day, drawing details from the *Last Supper*. Warhol put drawing paper on the back of the door with masking tape and used a projector for the image he was basing his drawing on. He did the head of Christ (fig. 57) over and over again and also sketches of Christ's hand (fig. 58) next to the glass of wine, or Peter's hand holding the knife, or groups of the apostles. There are many of these drawings showing Warhol's hand in flight as he recreated with quick strokes of the brush, chosen areas of the large scene. This group of drawings is both finished works of art and studies—studies that fed into the eight or more huge, hand-painted canvases of the entire composition.

Among these large paintings, the *Last Supper* with the Wise Potato Chips logo (fig. 59) is striking. Again the scene is set before us, but our attention is riveted by the huge, brilliant blue-and-black logo that rotates in space between us and the table, obscuring some of its occupants. The Wise Potato Chips logo is

an abstracted head of an owl, compressed into a circular design. It is an advertising device, with a play on the word "wise," since the owl is a symbol of wisdom. But Warhol applied the paint so freely that the repeated circular forms are thrust into movement; the logo spins before us with a primordial energy which, as Heiner Friedrich said, suggests the creation.[6]

 In the commanding and mysterious untitled *Last Supper* with Christ and two apostles (fig. 60) we again see Warhol's revisualizing, rearranging, rethinking the core group in Leonardo's mural. Two Christ figures are depicted side by side, but the Christ at the right is enlarged, making his right hand hover over the bread and bringing his image nearer to the viewer. The figures of the argumentative Thomas with his finger raised and James with his arm wingspread in astonishment are sketched in a soft gray, dematerializing the apostles. A provocative omission is that of the wine glass next to the outstretched right hand of Christ in Leonardo's mural. This glass is present in Warhol's untitled painting of Christ and St. John (fig. 66), where Christ's right hand moves toward the wine glass, one of his fingers being visible through the transparent glass, as in Leonardo's mural.[7] But in this painting the glass with its eucharistic wine is missing. A

 The Religious Art of Andy Warhol

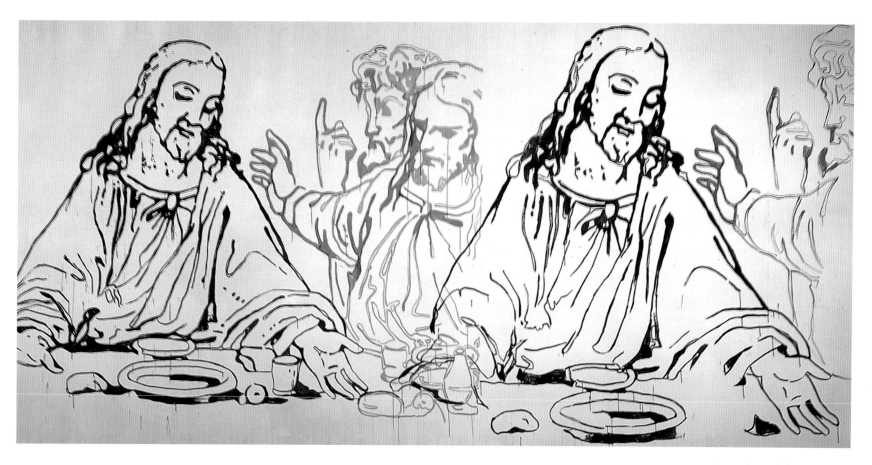

60. Andy Warhol, *The Last Supper* (Christ, St. Thomas, and St. James), 1986. Synthetic polymer on canvas, 113 x 228 in.

lone wine glass is seen next to the left hand of Christ, but this hand gestures toward the bread: the Christ at the right has neither bread nor wine at his left. Oddly, the shadow of the missing glass is conspicuously delineated.

Is Warhol reflecting a liturgical parallel experienced in his own churchgoing? The absence of the wine glass suggests the practice at the church Warhol attended in his last years, St. Vincent Ferrer, where only the consecrated bread was offered to the congregation at Mass, but not the wine. This was often the case in Catholic churches in pre–Vatican II days and is still the usage in most churches. In the Byzantine Rite Catholic churches Warhol attended in his Pittsburgh years with his family, however, both consecrated bread and wine were offered at Mass.

The large double painting *Be Somebody With a Body* (fig. 61) crowns the series of this title. The image and the title are taken from an advertisement for bodybuilding; the healthy young man with arms crossed over his bare chest who looks expectantly upward is repeated in several forms by Warhol, as a silkscreen print, and in smaller paintings of several sizes. Some of these have the figure of Christ of the

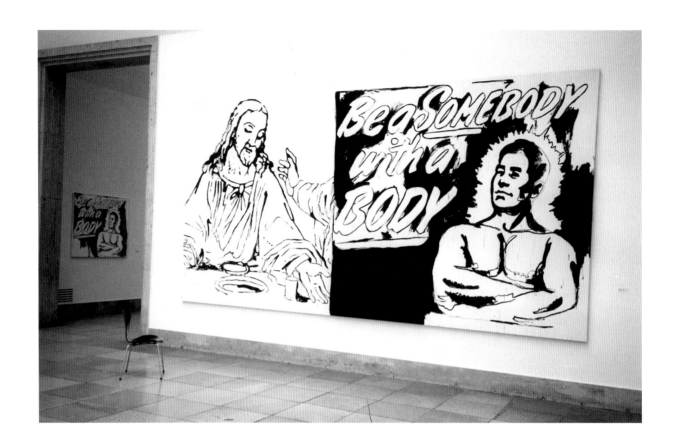

63. Above Andy Warhol photographed ca. 1950. His face resembles the young bodybuilder in *Be Somebody with a Body.*

61. Above left: Andy Warhol, *Be Somebody with a Body* (With Christ of Last Supper), ca. 1985–86. Synthetic polymer paint and silkscreen ink on canvas, 113 x 228 in.

62. Overleaf: Andy Warhol, *Be Somebody with a Body* (With Christ of Last Supper), 1986. Synthetic polymer paint and silkscreen on canvas, 23 x 23 in.

Last Supper superimposed (fig. 62) over the young bodybuilder. But in this large painting the two images are adjacent to each other, enlarging the meanings of both. The Christ, large in size and physicality, seems to reach with his left hand toward the young man linking the Christ with the smiling young man whose head is haloed. The black contours of Christ are inscribed against a phosphorescent white background which contrasts dramatically with the dark zone surrounding the bodybuilder. The luminosity of his body and the encompassing white radiance about his head show him transfigured and haloed.

At the time that Warhol did these paintings, he was involved in his own bodybuilding program, exercising and working out regularly with a trainer. Though the bodybuilder was taken from an advertisement, there exists in the Warhol Archives a snapshot of Andy (fig. 63) as a young man smiling and looking upward, which has a general resemblance to this bodybuilder.

The boldest of the hand-painted canvases based on Leonardo's *Last Supper* is the Warhol Museum's thirty-foot-long canvas titled the *Last Supper (The Big C)* (fig. 64) with four images of Christ and the group at the left of Thomas, James, and Philip painted in various sizes with the startling addition of three motorcycles as well as logos and a price tag. The primary colors, red, yellow, and blue, highlight the logos and the largest motorcycle. Warhol copied a newspaper heading for an article titled "THE BIG C: Can the

The Religious Art of Andy Warhol

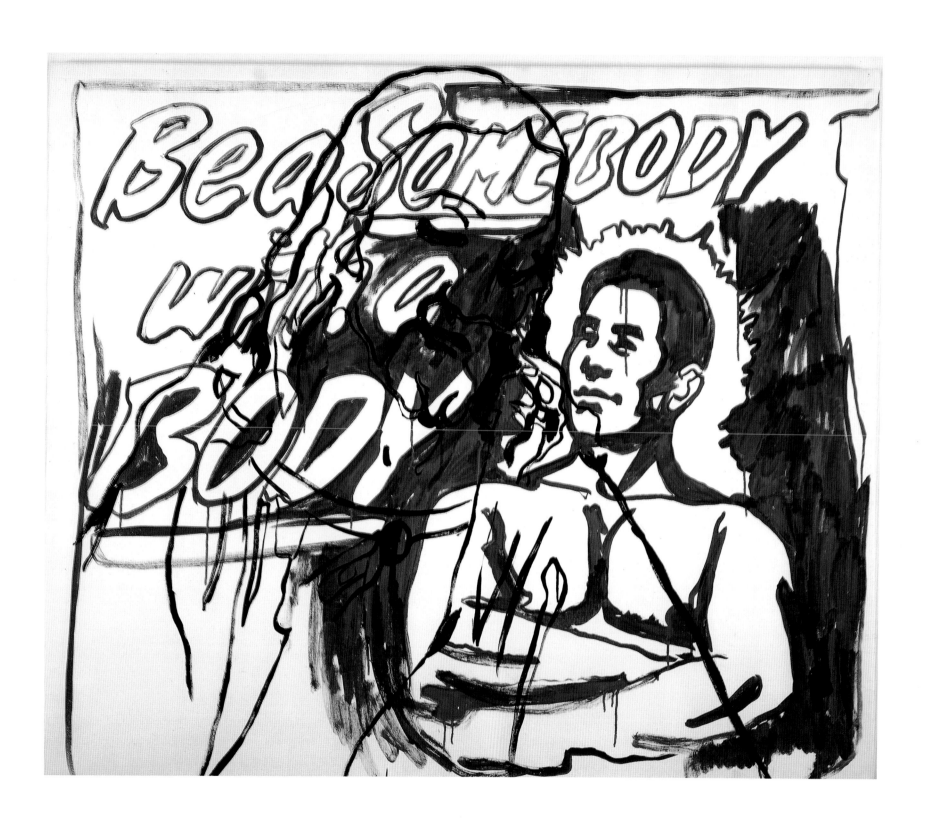

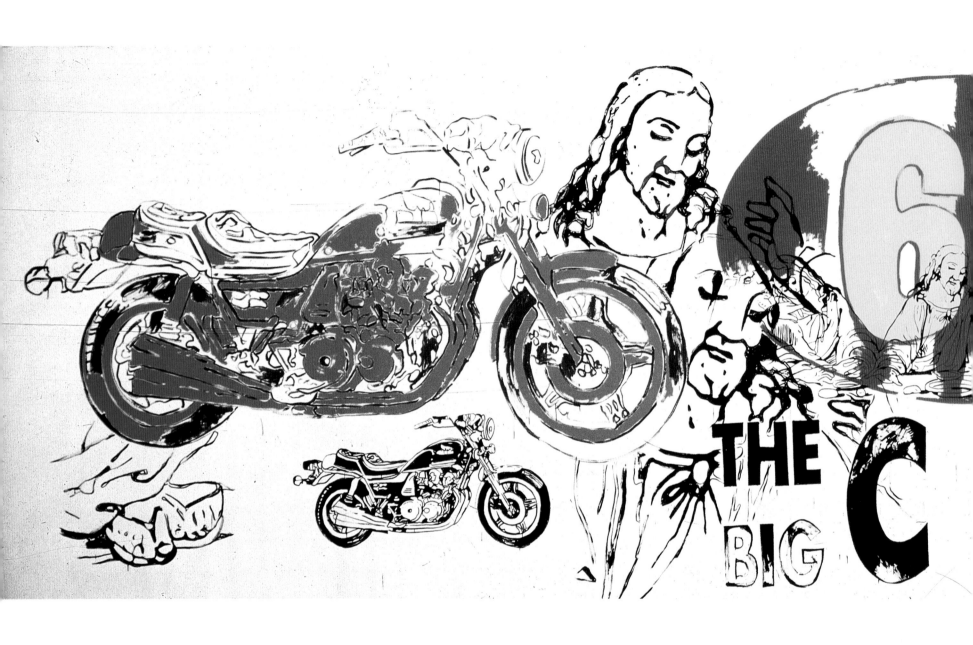

The Religious Art of Andy Warhol

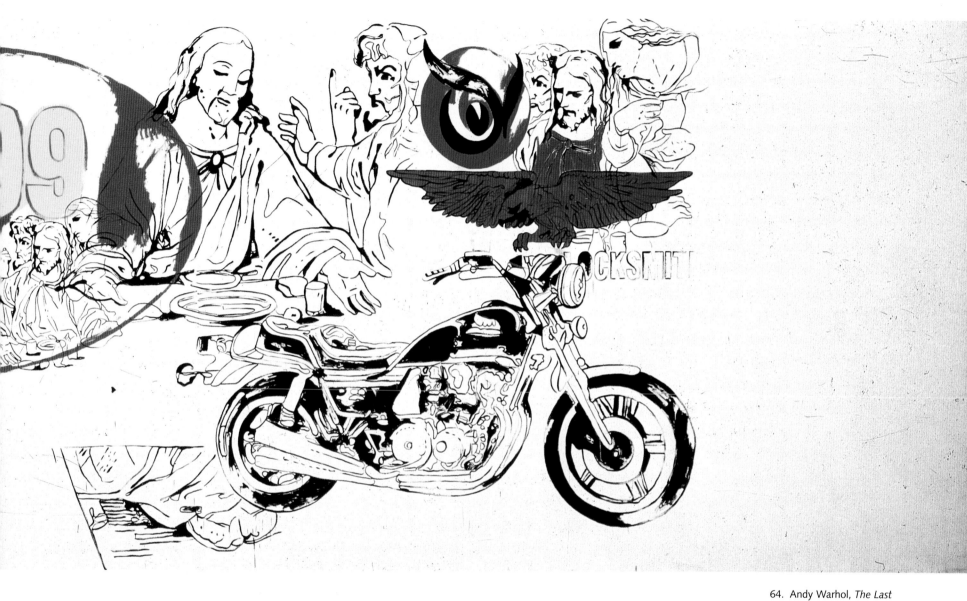

64. Andy Warhol, *The Last Supper (The Big C)*, ca. 1985. Synthetic polymer paint on canvas, 116 x 390 in.

Mind Act as a Cancer Cure?" The heading, like so much of his source material, was taped to cardboard (along with a Dove soap label and a Heinz 57 label) and kept by the artist, who never threw anything away. Warhol's anxieties for his own health, a legacy of repeated childhood illnesses and physical frailty, intensified as the years passed. The *Diaries* report, "the other night I had a blackout like I used to have when I was little . . . it got me so scared that I'm having a brain tumor."[8] In this vast *Last Supper* painting the reference to the fearful scourge of cancer, "The Big C," is surrounded by small, big, and bigger images of Christ. The Christ is another *Big C*.

The large price tag, which partially obscures the central figure of Christ and the five apostles nearest him, could suggest that money and material needs stand between the viewer and the Christ. The brilliant colors and disjunctive placing of images of Christ in black outline give the large painting a bruising, confrontational immediacy.

Warhol's juxtaposition here of the Christ of Leonardo with the motorcycle, our age's symbol of untrammeled freedom, power, and sexuality, results in a brash and commanding painting. Two sides of Warhol, his piety and his deep involvement in the aspects of the culture that are inimical to that piety, are here asserted and held in an unresolved tension.

Charles Stuckey comments on the mural scale of this painting with its hybrids of sacred and profane metaphors. He likens it to the juxtapositions of biking and religion in the cross-cutting in Kenneth Anger's underground film, which moved from scenes taken from a Bible school movie to those of a motorcycle gang.[9] Is it only a coincidence that the wheel of the motorcycle at the right presses upon the foot of Jesus, reminding us of Warhol's frightening *Foot and Tire* of 1963, where we see a gigantic tire crushing down upon a human foot?

The encyclopedia outline drawing was used for the *Last Supper (Dove)* (fig. 65) owned by the Museum of Modern Art in New York. Again, in transcribing the lines of the room in Leonardo's *Last Supper* Warhol left the side walls empty except for one flourish derived from the tapestries at the right. But these details are scarcely noticed because our attention is riveted by the obscuring and alien commercial logos that jump forth at the viewer: the corner of the price tag for 59¢, the Dove soap logo, and also the General Electric logo. The wit and humor of juxtaposing the sacred and the secular engage and startle the viewer. What was Warhol up to here? He never chose an object, an image, or a logo randomly. So what are these advertising and marketing labels doing obscuring the contours of the *Last Supper*?

Dove in word and image is familiar from Dove soap packages, and GE from packaged light bulbs: electricity and soap, thus power and cleanliness. Some will remember the old adage "Cleanliness is next to Godliness." Significantly, the dove levitates above the head of Jesus. Andy was familiar with all the scriptural readings for the church year from his attendance at St. John Chrysostom Byzantine Catholic Church while growing up and from his regular churchgoing in New York. He would have known the

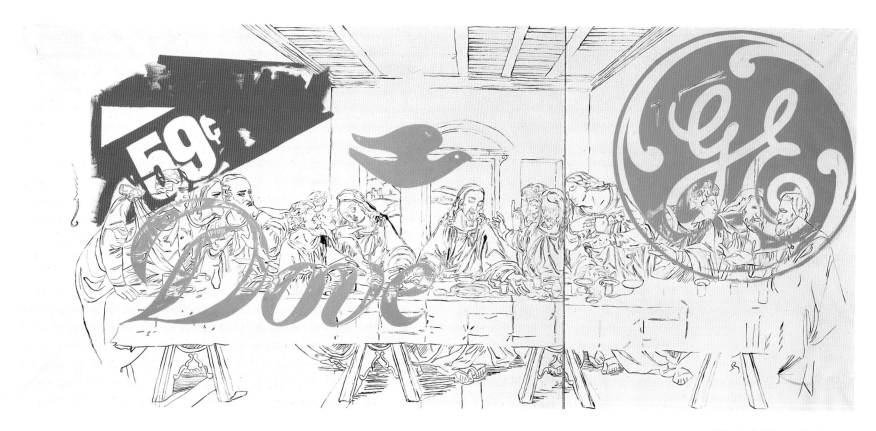

accounts of the baptism of Jesus by John the Baptist, when "the heaven was opened, and the Holy Spirit descending upon [Jesus] in bodily form like a dove" (Luke 3:21-22).

As for GE, "we bring good things to light" can be seen as a metaphor for creation, when God separated light and darkness and found his creation to be "good": God brings good things to light. GE as a symbol for the creator, the dove for the Holy Spirit, and Jesus here delineated at the Last Supper—the three make up the Holy Trinity. The Trinity of the Father, Son, and Holy Spirit is a theological concept that is particularly significant in the Byzantine Catholic Church. The price tag? Everything can be purchased? Or perhaps the meaning is that *not* everything can be purchased. Or again, the 59¢, which even in 1986 when Warhol did this painting, would not have bought much, may refer to a devalued currency and devalued religious images which are here juxtaposed. This arresting painting suggests multiple meanings. In contrast to the dominating, strident colors and bold black contours of the *Last Supper (The Big C)*, this painting has gentler colors and delicate lines. It is also considerably smaller, being slightly over twenty-two feet in width, in contrast to the *Big C's* thirty-two-and-a-half feet. There is an element of playfulness in this painting that does not erode the religious content: it is the believer who can mix the sacred and the secular with impunity.

65. Andy Warhol, *The Last Supper (Dove)*, 1986. Synthetic polymer paint on canvas, 119 x 263 in.

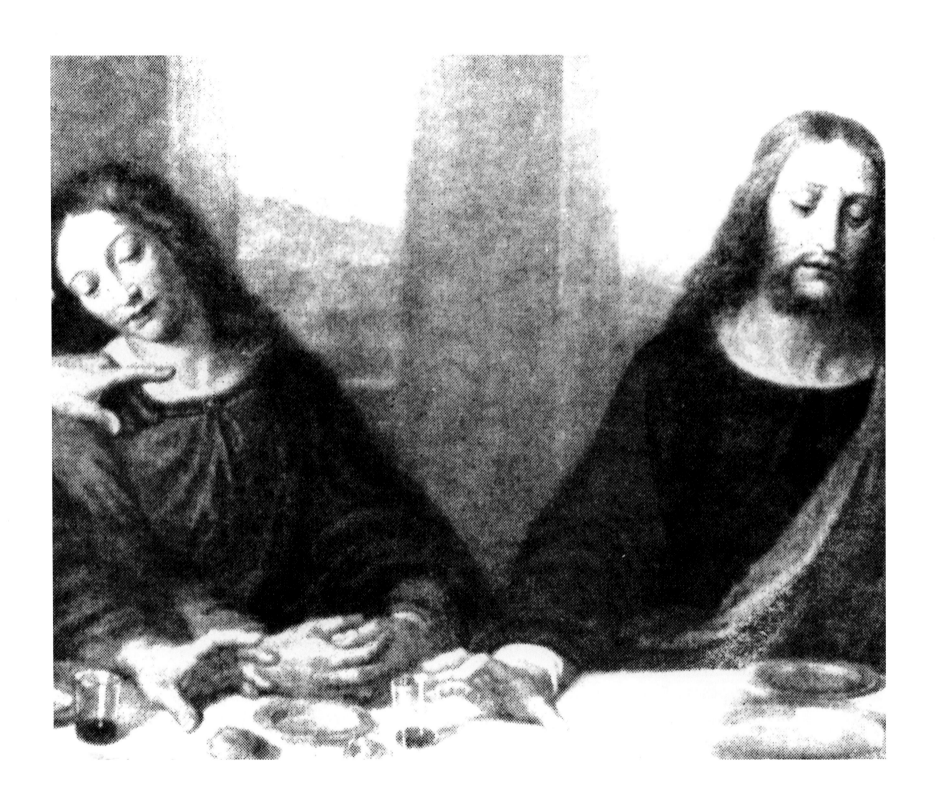

The Religious Art of Andy Warhol

In another picture Warhol chose to deal with the figures of Christ and St. John (fig. 66), emphasizing the extraordinary hiatus that occurs between the only quiet and meditative figures in Leonardo's busy scene. Christ and John, the beloved disciple, are physically separated by a ninety-degree angle, yet their outward similarity of physiognomy and their inner depths make the hiatus strangely alive. Warhol has increased the sense of connectedness of the two figures by muting the window moldings that cut into the space between the two in Leonardo's painting. We become intensely aware of the tremulous contours of the inverted triangle between the Christ and St. John.

Is a homosexual relationship between Christ and St. John suggested here by Warhol? Biblical scholars have, in fact, speculated on the possibility of such a relationship between Jesus and John because of the five references in John's Gospel to him as "the disciple Jesus loved." Leonardo himself, along with a group of apprentices in Verocchio's studio, was accused of homosexual relations but was acquitted. Nonetheless, Freud is not the only biographer who saw evidences of Leonardo's homoerotic tendencies in his work.[10] In the case of Warhol, his intense voyeurism is documented. His attraction to young, handsome men friends and helpers is expressed in his beautiful drawings. Whatever the complex sexual and emotional drives within Warhol, the picture of Christ and St. John has a formal beauty that is impregnated with a sense of tenderness, warmth, and intimacy.

The strangest of all these Christ images are the ten white boxers' punching bags (fig. 67) owned by the Warhol Museum which have the Christ image drawn on them by Warhol with additional designs and phrases painted by Jean-Michel Basquiat. Jean-Michel was a young black artist born in Brooklyn of Haitian-Puerto Rican parents. The dealer Bruno Bishofberger brought him to see Andy in 1982, and thereafter Warhol's *Diaries* detail their social activities and occasionally mention their numerous collaborations, which began in 1983. Warhol credited Basquiat with getting him "into painting differently. So that's a good thing."[11] Basquiat had admired the older artist—he was twenty-two and Warhol then in his early fifties—and they became friends and collaborators.

Basquiat's graffiti-like scrawlings deface the image of Christ and have taunting street terms conspicuously scrawled across the punching bags. What prompted the artists to paint these punching bags—ten of them—with the image of Jesus derided on them?

Jay Shriver, Warhol's assistant in the eighties, told of the circumstances surrounding their creation.[12] It was the coincidence of a number of factors and timing as he put it, that gave Andy the idea. Warhol was then concerned about his health and had a personal trainer come to his office every other day: boxing was a part of the program. The offices had recently been moved to the former Consolidated Edison building on 33rd Street, in which Warhol's studio was a huge open room; thus there was ample space for the ten punching bags, which were probably acquired through Andy's trainer. Warhol had seen a punching bag that Basquiat (who was a boxing fan) had painted derisively with the image of his dealer,

66. Overleaf: Andy Warhol, *The Last Supper* (Christ and St. John), 1986. Silkscreen on paper, 23½ x 31½ in.

The Religious Art of Andy Warhol

Mary Boone, with whom he had a falling out. Warhol thought it was "really great." He had the ten bags installed in his spacious studio. He was, at the time, deeply engrossed in the paintings of Leonardo's *Last Supper* for his friend art dealer Alexandre Iolas's inaugural exhibition for his new gallery in Milan.

In their collaborations Basquiat and Warhol went back and forth to each other's studios. When Warhol had finished, Basquiat overpainted in his graffiti style words and images from his own artistic vocabulary. At the time Basquiat was getting criticism from a segment of the art world about being Warhol's "mascot" and the defiance in his repeated "judge," inscribed on the face of Christ as well as elsewhere on the bags, may reflect his anger at his critics.

Warhol too had had negative reviews from the art press, and though he had shows in Paris and a retrospective that traveled to European museums in the sixties, his first retrospective to be shown in the United States was not until 1970 at the Whitney and elsewhere. The grand arbiter of contemporary art, the Museum of Modern Art, never gave him a show in his lifetime. Furthermore, his friend Henry Geldzhaler had exhibited Roy Lichtenstein's work rather than Andy's in the Venice Biennale, the year he was commissioner for this prestigious show.[13] Both artists may have identified with the persecuted Christ.

The violated image has a parallel in scripture and in religious iconography, the flagellation of Christ. Warhol had chosen a painting of this subject for an exhibition he composed for the Museum of the Rhode Island School of Design from the varied collections in their storage vaults in 1970.[14] All four Gospel narratives recount that Pilate, the provincial Roman governor who acted as judge and heard accusations made against Jesus, finally released Jesus to be scourged before his crucifixion. The scourging of Jesus, or his flagellation, occurs frequently in art from medieval times through the seventeenth century. Basquiat also had a religious upbringing, and like Warhol would have known paintings of this subject, since it was part of the many series of works on the Passion of Christ. Northern artists like Bosch and Dürer represented the flagellation with sadistic violence; in their works Jesus is the meek recipient of bodily blows that opened wounds all over his exposed body and face. The Christ image on the punching bags is the sad, withdrawn, hand-painted visage that we have seen in Warhol's paintings, but on the punching bags it is defaced by epithets and scrawlings—a scourging by word and potentially by deed.

It was the coincidence of many factors—the large working space, both artists' interest in boxing, Basquiat's derisive punching bag with his dealer's image on it, and finally, Warhol's deep involvement with the Leonardo Christ of the *Last Supper* which had fired his imagination—that lay behind this strange ten-part flagellation. Was the collaboration of the punching bags done as an outrageous spoof, or with resentment by the two defiant artists, who were no longer communicants in the church in which they had been brought up? Perhaps it was a mix of these motivations and others within the artists' psyches. Jay Shriver said that both were aware of the religious theme and that their intention was not irreligious.

Warhol's preoccupation with the Leonardo Christ is most dramatically evident in four immense

67. Overleaf: Andy Warhol and Jean-Michel Basquiat, *Ten Punching Bags* (With Christ from Last Supper). Acrylic and oil stick on punching bags, 42 x 14 x 14 in.

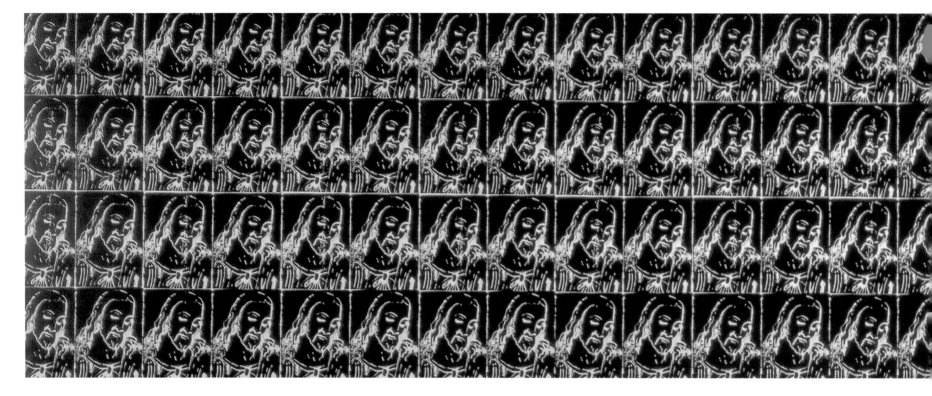

68. Andy Warhol, *Christ 112 Times*, 1986. Synthetic polymer and silkscreen ink on canvas, 80 x 421 in.

69. The black and white version of *Christ 112 Times* rolled up in storage, before mounting on stretchers.

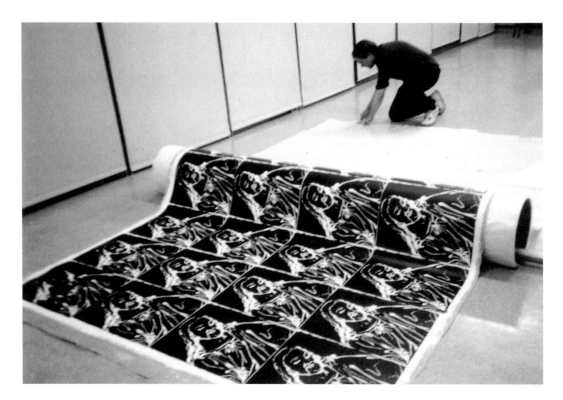

The Religious Art of Andy Warhol

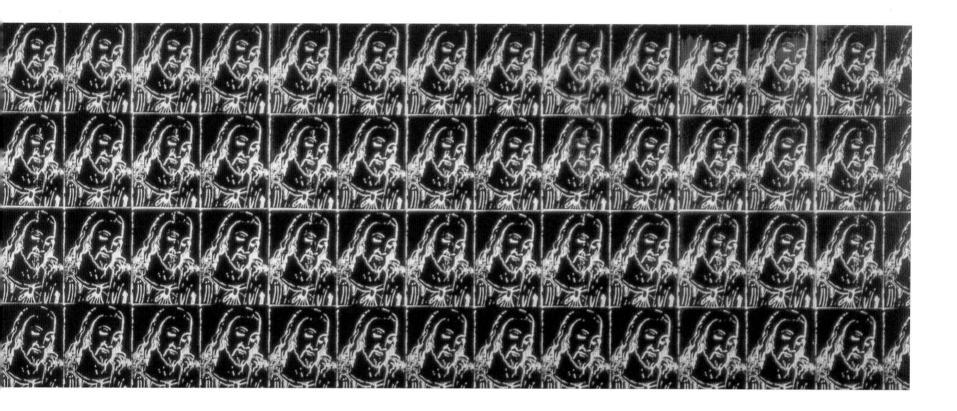

silkscreen paintings that are more than thirty-five feet in width, each having the image of Christ repeated one hundred and twelve times (fig. 68). In the black-and-white paintings four of the heads of Christ are placed vertically and twenty-eight run horizontally. In this vast panorama (fig. 69) of repeated, negative images[15] the face, features, and shoulders of Christ at first lose their identity and dissolve into an abstract, black-and-white pattern. But gradually the faces recover their identity, then are lost again in the wavelike motion of the seemingly overlapping contours. The repetition is incantatory and may, for the attuned viewer, act as a visual chant. Warhol had a special sense for shape and size; here he pushes dimensions to the limits, suggesting indeed that the images could be repeated beyond space and time, infinitely.

In these last paintings the cool and distanced artist abandoned his mask. Warhol finally created paintings in which his secret but deeply religious nature flowed freely into his art. His earlier paintings with religious themes, such as *Raphael I-6.99,* which depicts the *Sistine Madonna,* and his prints based on Renaissance religious paintings, are cool and affectless, having only a tenuous connection with his piety. In the *Last Supper* paintings, however, Warhol was himself engaged at a level deeper than his habitual piety. Warhol repristinated Leonardo's mural, recreating it and making it accessible to twentieth-century sensibilities, widening its meaning beyond the particularities of Christian belief to a more encompassing, universal affirmation, what George Steiner called "the wager on God."[16]

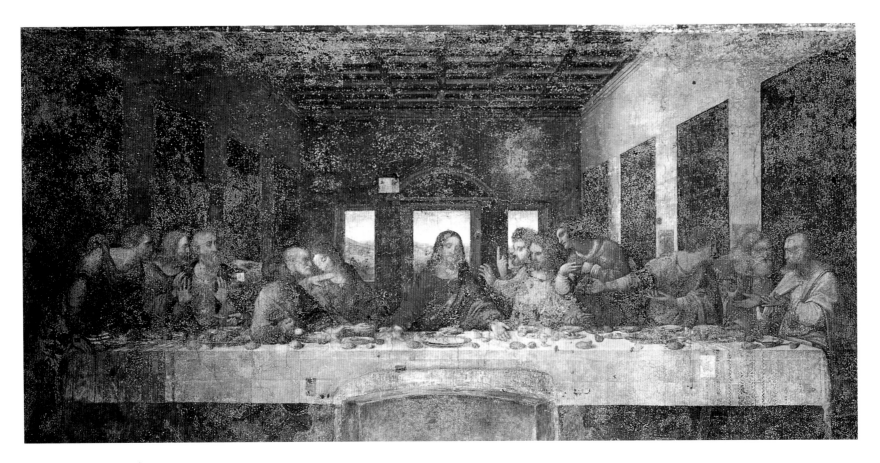

70. Leonardo da Vinci, *The Last Supper,* 1498. Tempera on prepared stone wall, 180 x 342 in.

5: Warhol and Leonardo in Milan

When his Last Supper was displayed in Milan, a kind of citywide two-man show with Leonardo, 30,000 people flocked to see it. . . . When the final multivolume Popular History of Art *is published, ours will be the Age of Warhol—an unlikely giant, but a giant nonetheless.*
—Arthur Danto, *Encounters and Reflections*

When Alexandre Iolas (Warhol's friend and one of his first art dealers) saw some of the *Last Supper* paintings discussed in the previous chapter in Warhol's studio, he commissioned him to do a series for the inaugural exhibition at his gallery in Milan. The gallery in the Palazzo delle Stelline was across the piazza from Santa Maria delle Grazie, where Leonardo's famous mural covers a wall of what was in the late fifteenth and sixteenth centuries the refectory of the Dominican friars (fig. 70). Warhol, excited by the commission, returned to this theme with renewed fervor as he began to work on the silkscreened paintings for the Milan exhibit. Vincent Fremont, his executive assistant, said that "Andy was on a creative roll."[1]

In a 1986 interview, the last before his death, Warhol reported that he had done about forty paintings of the *Last Supper*.[2] Twenty of these, all silkscreened, were shown at the exhibition, which opened January 22, 1987.[3] The Milan editor of Warhol's magazine *Interview* reported that the opening was "the biggest event to ever happen in Milano: the gallery expected five or six hundred people, but five or six thousand came."[4] It was later reported that thirty thousand people saw the exhibition during the Milan showing. Warhol had been widely exhibited and his importance acknowledged in Europe before he achieved recognition as an artist in this country.

The *Last Supper* series was Warhol's last major cycle of paintings, and the opening of the Milan exhibition was his last public appearance. The French art critic Pierre Restany, who was at the opening with Warhol, told how this "series appeared as an extension of the now-inaccessible message of Leonardo's famous masterpiece: a sort of replay and reactualization of the original fresco, an act which took on all its

symbolic value on the white walls of the Palazzo delle Stelline," which was a defunct convent that had been made into a gallery situated fifty meters from the Leonardo *Last Supper.* "It was a beautiful Lombard winter day, a limpid sun which conferred on Warhol's work a strange aura of spirituality." Restany continued, "Andy, fascinating in his mauve-tinged platinum wig [fig. 71] which gave him a half-mourning air, seemed penetrated by the importance of the moment. He greatly surprised me when he said to me: 'Pierre, do you think that the Italians will see the respect I have for Leonardo? . . . Consciously or not, Warhol seemed to me to having acted there as a curator of a masterpiece of Christian culture, of maintaining a tradition he was a part of."[5]

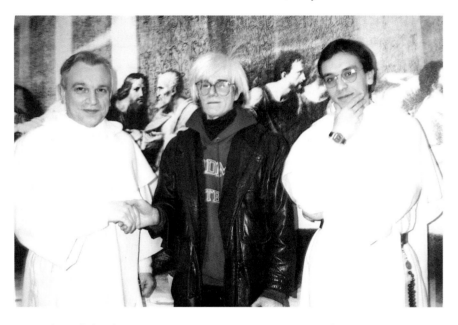

71. Andy Warhol and two Dominican priests at the exhibition Warhol: Il Cenacolo in Milan, January 22, 1987.

One month later, February 22, Warhol died suddenly and inexplicably in a New York hospital after gall bladder surgery. The cause of death was never determined. The Milan exhibition was closed soon after. Alexandre Iolas intended that those who saw Andy's exhibition would walk across the Piazza to the vast room where Leonardo's *Last Supper* was in the process of being scrupulously cleaned, leaving only a shadow of the original when the conservationists had completed their work. At the time of Warhol's exhibition, the right side of Leonardo's mural had been cleaned as far as the left hand of Christ, leaving the cleaned area drained of color, a substanceless mirage.

Even this most recent tampering with Leonardo's original, which had accretions of overpainting accumulated during the nearly five hundred years since its completion, has not diminished in any way the hold Leonardo's painting has on the collective Western imagination. Many copies of all sizes have been made, some during Leonardo's lifetime. Engraved copies had carried the composition all over Europe. The printing press and modern reproductive techniques have made the image ubiquitous. There are beautiful paintings of the Last Supper by other great artists—Giotto, Sarto, Titian, Rubens, Tiepolo, to name a few—but none of these have achieved the widespread familiarity of Leonardo's composition.

Why is it that Leonardo's *Last Supper* is the one imprinted on our consciousness? Art historians and art critics have provided illuminating analyses, but while they help us to see more deeply into the painting, they do not seem to account for the appeal of Leonardo's work across centuries and cultures.[6] By the time Warhol appropriated Leonardo's *Last Supper*, it had long been part of popular culture.

Andy Warhol took the cheapened and distorted copies, and with the alchemy of an artist, he transformed Leonardo's *Last Supper*, recreating it again and again in ever new variations. Warhol gave the vulgarized and secularized image a new seeing.

The Pink Last Supper

When one first sees the pink *Last Supper* (fig. 73), there is a moment of shock at viewing two replicas of Leonardo's original mural set side by side. The ambient pink-pinkness of the scene is also startling. But it is surprising how quickly seeing and feeling are accustomed to this doubleness and this pinkness. Warhol began by covering the thirty-two-foot-nine-inch canvas with pink acrylic paint. Then, using four silkscreen panels for each of the two side-by-side scenes, he used black paint for the images. The screens had been prepared with a coating of photosensitive emulsion. It was then exposed to a photographic slide. On being developed with hot water, the emulsion dissolved leaving fabric in the unexposed areas in its original state, while the exposed areas have been imprinted with the photographic image.[7] By pressing ink through the screen onto the canvas, an accurate, detailed image was obtained, and an unlimited number of prints could be run off. The screens used for the pink *Last Supper* were, in all probability, also used for the yellow *Last Supper* in the Baltimore Museum and for the red *Last Supper,* owned by Gallery Bruno Bischofberger Zurich.[8]

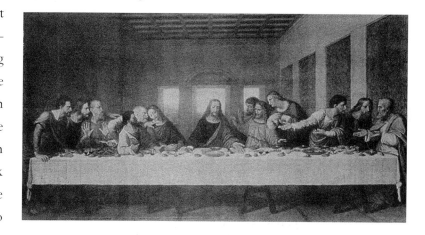

72. Source for Warhol's silkscreened *Last Supper* paintings, ca. 1986. Photostat, 7¾ x 9¾ in.

The photograph of the Leonardo mural (fig. 72) that Warhol used as a basis for his silkscreened pictures of the Leonardo mural is preserved in the Warhol Museum in Pittsburgh. The photo is of an engraving that is close to a widely distributed version by Raphael Morghen done in 1800. Gratuitous additions and changes to Leonardo's original occur in most copies. The copy made by Andre Dutertre in 1789 for King Louis XVI of France is thought to be the most faithful "reconstruction" of the original, which even in the eighteenth century was in a terribly damaged condition. Dutertre's copy, however, became known only in 1958, when it came into the possession of the Ashmolean Museum in Oxford.[9] Though Dutertre's copy has been published, it is unlikely that Warhol was familiar with it. Rupert Smith, Warhol's studio assistant, reported that "the actual photo of the Last Supper he used I bought at a Korean religious store next to the Factory. It was one of those copies of the 19th century version that had been re-done, like you'd buy in Woolworth's."[10] As in his Pop paintings, Warhol chose as his beginning point not the best available reproduction but rather a common photo "like you'd buy in Woolworths."

Why two images? Warhol had used the bifocal composition before in many of his portraits, where the two faces confront the viewer, the images being almost identical but the colors and shadows varying, thus suggesting two moods and differing insights into the person portrayed. But in the pink *Last Supper* the black images are identical, and the background a uniformly glowing pink. The two scenes of the *Last Supper* are anchored by the long horizontal of the table coverings which fall along the edge of the table. Since

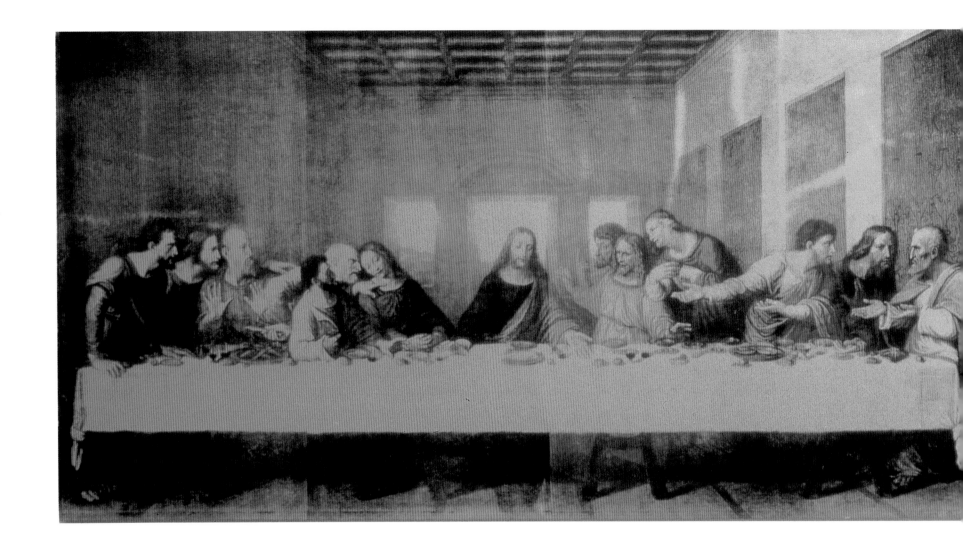

these appear to be in our space (on our side of the picture plane, that is, the plane of the picture itself),
they draw our eyes to the table, with its still life of fruit, rolls, transparent glasses, plates of small fish, and
then to the hands of the apostles and their varied gestures. Peter's hand, which holds a knife, appears dis-
embodied since Judas's figure covers most of Peter's torso. It is this hand of Peter and this knife that later
the same evening in the garden of Gethsemane will cut off the right ear of Malchus, the high priest's
slave.

In Leonardo's original the repertoire of gestures has a somewhat rhetorical character, these being
elements in a grand Renaissance composition. In Warhol's appropriation the same gestures seem to have
more spontaneity and immediacy, an effect gained by the double-focus image and by having the frame-

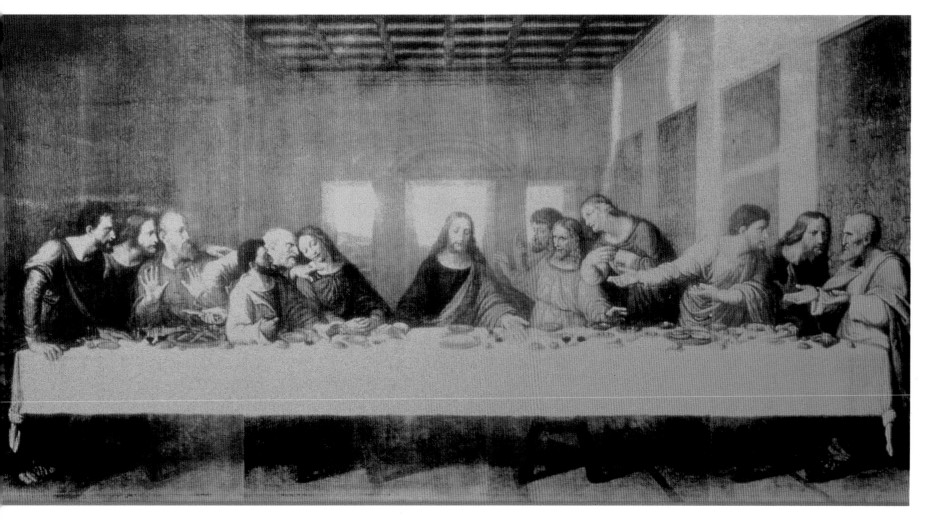

73. Andy Warhol, *The Last Supper* (Pink), 1986. Synthetic polymer paint and silkscreen ink on canvas, 78 x 306 in.

less picture hung low and accessible to our eyes and sensibilities. The scene seems to merge with our space, and we peer at the faces all the more intently as they cluster about the central, still body and remote face of the Christ. Pink—our associations are with baby pink, with blushing, and with flowers, all suggesting life, vitality, arousal. Black is associated with night and death. At the Last Supper, Jesus foretold his own death, which was to open the way to eternal life. Life and death in this pink *Last Supper* are locked together in a glowing pattern, asserted once, and once again.

Black and pink were a "Mod" combination used in high fashion, interior decoration, and car exteriors in the fifties. The combination was revived in the late seventies and eighties. Warhol himself planned to paint a BMW car in pink and black.[11] Attuned as always to the shifting styles in fashion and

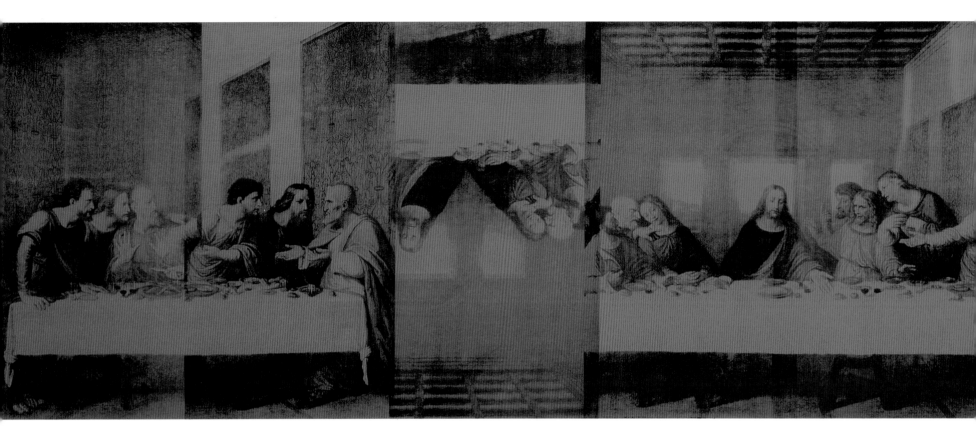

popular culture, Warhol used a Mod combination for a painting that transcended the time-bound, evoking the timeless.

It has been suggested by Mark Francis that Warhol saw in the gathering about the Christ at the table something of an "allegory of the dramas and disputes that reigned in his own studio with himself as the central, powerful figure."[12] Work, meals, and partying all merged in the Factory and Warhol's successive work spaces. It was an association that might indeed have occurred to Warhol. He called his workers his "kids" and had a somewhat paternal attitude toward them, but he also could be alienating. To view his role as akin to that of Jesus does not seem beyond the complex and volatile imaginings of Warhol's nimble mind. It would probably be dismissed with humility a moment later—and many of his friends and associates speak of his humility. Dürer went even further and used his own features and body to represent Christ. Dürer's painting hangs in the Metropolitan Museum, where Warhol would have seen it. Paul Gauguin, James Ensor, and Robert Mapplethorpe, to name but a few nineteenth- and twentieth-century artists, also depicted themselves as Christ. These works of art belong to a tradition in Christian iconography of the artist as Christ, the *alter Christus*.

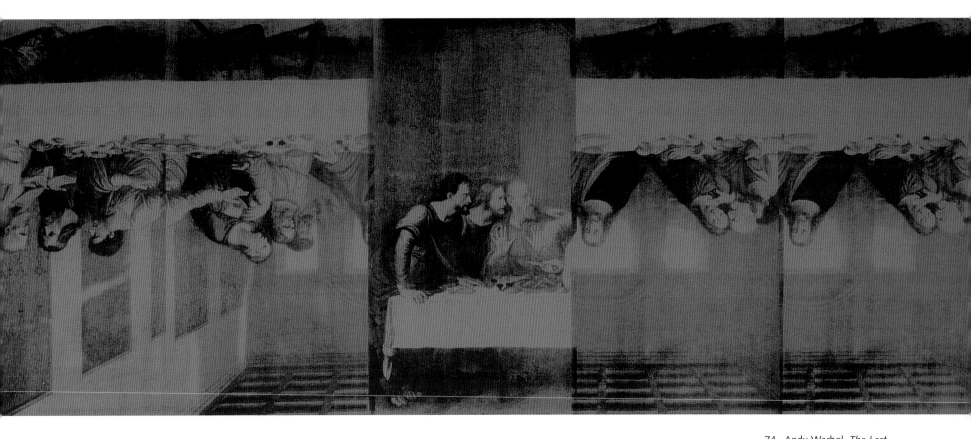

74. Andy Warhol, *The Last Supper* (Red), 1986. Silkscreen ink on polymer paint on canvas, 78 x 400 in.

The Red Last Supper

Two radically transformed *Last Suppers* crown the series and Warhol's oeuvre, the red *Last Supper* (fig. 74) and the Camouflage *Last Supper*. The red *Last Supper* is majestic in size. It is the same height as the pink painting but is longer, expanded to almost thirty-four feet. At first viewing, this glowing red painting is startling with its upside-down panels adjacent to right-side-up panels. Leonardo's carefully structured unity of the figures with their ebb and flow around the pivotal figure of Jesus is shattered by what seems an arbitrary cutting up and shuffling of the component groups. The effect should be disorienting, or, at the very least, disquieting. Surprisingly, it is neither. The strong vertical of the glowing red tablecloth with the velvet black shadows below the cloth knit the composition together. Looking from left to right, this black and red horizontal is at the lower edge of the painting: then, as a screen is inverted, this strong vertical appears at the upper border and continues to alternate top and bottom as the eye moves from left to right.

The rhythm of these alternations is slow moving and lyrical. When we study the painting with care, we discover how much virtuosity and imagination Warhol used in the placing and repeating of the

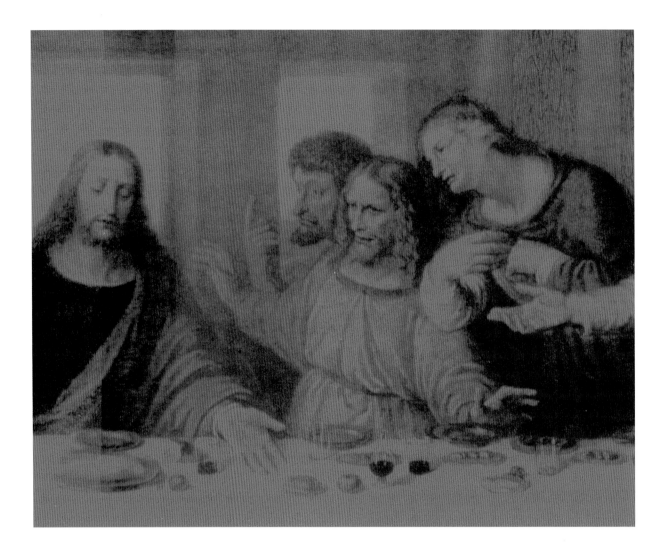

Detail from *The Last Supper* (Red), fig. 74.

silkscreen panels. The painting has two complete Last Supper compositions, but, additionally, the silkscreen panel with Christ, John, Peter, and Judas is repeated twice again, making four of these panels in all. Peter, John, and Judas, to whom Warhol brings special emphasis, are those who have speaking roles at the biblical Last Supper, beyond the corporate response of all the apostles. When Jesus announced the imminent betrayal, Judas, who betrayed him, asked, "Is it I, Master?" to which Jesus replied, "You have said so." Peter beckoned John and said, "Tell us who it is of whom he speaks." And John, addressing Jesus, said, "Lord, who is it?" (Matthew 26:25; John 13: 25). Thus, John, the beloved disciple, and Peter, who would be given authority to lead the early church, together with Judas, the betrayer who left the table with Jesus' malediction "Woe to that man by whom the Son of Man is betrayed. It would be better for that man if he had not been born" (Matthew 26:24), constitute the core of the drama, along with the serene and remote

Jesus. It is this group that Warhol repeats four times over. Viewed from a distance, the red *Last Supper* becomes an abstract composition; gestures and postures are seen not in their singleness but as constituent of the wave-like rhythm within the larger up-and-down rhythms of the dark shadow, then the bright tablecloth zones.

Warhol removes us from the description of the event, releasing us into a distillate of the power of the event. Red, the color of blood, recalls Jesus' words as he offered his disciples wine at the Last Supper, "Drink of it all of you; for this is my blood of the new covenant" (Matthew 26:27–28). Black is associated with death, that is, Jesus' death, foreseen by him in his discourse at the Last Supper when he predicted, "I will drink no more of the fruit of the vine, until that day when I shall drink it new in the Kingdom of God" (Mark 14:25).

The Camouflage Last Supper

The Menil Collection's *Camouflage Last Supper* (fig. 75) is one of the largest and most somber of the silkscreened *Last Supper* paintings. It is also a mysterious and moving painting. Leonardo's image again is duplicated side by side but is covered with a camouflage pattern, which envelops the entire twenty-five-and-one-half-foot wide canvas. The camouflage pattern spills over the vertical edges, functioning as a kind of frame on either side. In the two *Last Supper* depictions, which are duplicated next to each other, the camouflage pattern covers and partially veils the features of Jesus' face as well as the faces of the two groups of apostles to the left and right of him. In the groups at either end of the table the picture-puzzle pattern of camouflage has odd-shaped, light-toned areas that seem to highlight the eyes of Simon and Jude at the extreme right in both scenes. The apostle Jude, who is second from the right, looks anxiously and searchingly toward us. The three apostles at our left, Bartholomew, James the Greater, and Andrew, seem to peer at the Christ with intensified emotion.

The restless, bold contours of the camouflage make the reading of the image difficult. What was Warhol's intention? Perhaps the answer lies partially in the function of camouflage: to conceal and to protect from harm and thus to preserve, in this case, the central mystery of the Eucharist. Another possible meaning is related to Warhol's own religious position. He was brought up in a devoutly Byzantine Catholic family, and he habitually attended and participated in the Divine Liturgy, the Byzantine eucharistic celebration. At some point in his adult life that pattern changed, and though he was physically present at Mass, he no longer participated in the Eucharist.

In a conversation with the prior of St. Vincent Ferrer, the church Andy attended during his last years when he lived in his 65th Street townhouse, it was reported that Andy often came alone into the

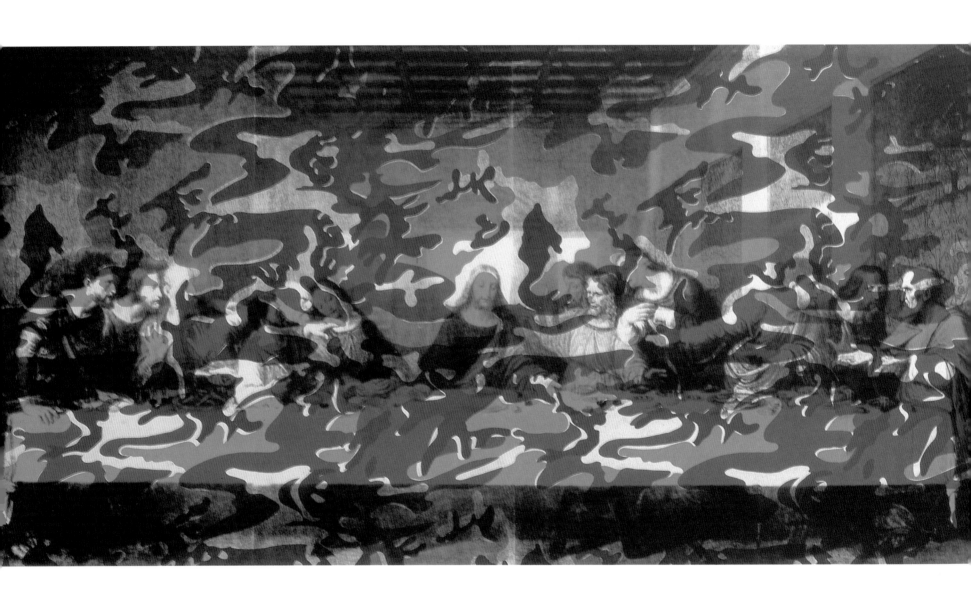

The Religious Art of Andy Warhol

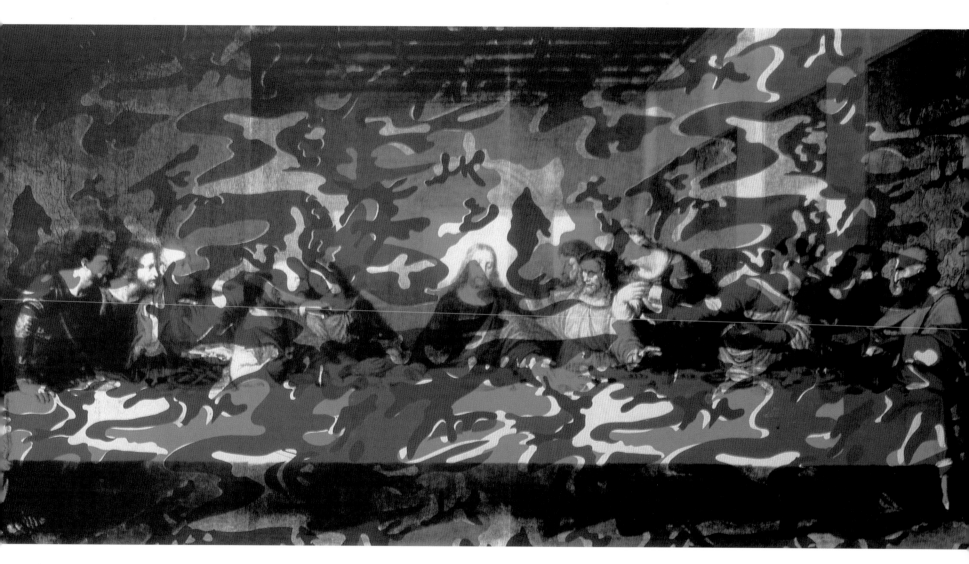

75. Andy Warhol, *The Camouflage Last Supper*, 1986. Silkscreen ink on synthetic polymer paint on canvas, 78 x 306 in.

church but he never went to confession or communion. The priest, Father Sam Matarazzo, said that he came not only on Sunday but several times a week, sitting or kneeling in the shadows at the back of the church, and leaving without speaking to anyone. Father Matarazzo said that he preached regularly against homosexuality, and that whatever Warhol's sexual life was, his life-style might be in conflict with the teachings of the church.[13] Rather than rebelliously leaving the church as many of his Catholic "kids" at the Factory had done, Warhol continued a secret—that is, a concealed—devotional life. Thus the camouflage, which functions as a cover-up and a protection, is symbolic of Warhol's own relationship to the church.

Did Warhol, who read Gertrude Stein's work, know of her account of the origin of camouflage? In her little book on Picasso (1938) she said, "I very well remember at the beginning of the war being with Picasso on the Boulevard Raspail when the first camouflaged truck passed. It was night, we had heard of camouflage but we had not yet seen it and Picasso amazed looked at it and then cried out, yes it is we who made it, that is cubism."[14] In 1907, Picasso and Braque had invented cubism, a style that reduced the three-dimensional things of the visible world to a flat, monochromatic pattern. In their cubist paintings the flat

Warhol and Leonardo in Milan

planes of muted color both concealed the forms represented and revealed another interpretation of reality. The army used muted, close-toned colors and the interlocking surface patterns similiar to those of the cubists for trucks and tanks, thus making them appear flat and formless when seen from airplanes or at a distance. These camouflage patterns were adopted for military gear and clothing, and became a "Hip" fashion. Warhol had bought a swatch of camouflage cloth at an Army-Navy store in New York and used its patterns not only for the *Last Supper* but also for a group of abstract paintings, varying the colors and shapes of the canvases. He also used the camouflage pattern for a group of late self-portraits in which a very large image of a cadaverous, white-wigged, tragic-looking Warhol peers toward the viewer with an unfocused, far-seeing gaze. In these portraits concealment and revelation strike a balance much as they did in Warhol's life. The public persona masks—that is, camouflages—the very private person.

Images of Christ

77. Leonardo da Vinci follower, *Christ the Savior*, ca. 1498 (study for the Last Supper).

The face of Leonardo's Christ was an obsessive preoccupation for Warhol. There are at least seventy Christ images known at this time, but when the complete catalogue of Warhol's works on canvas is available, this number will certainly swell as paintings sold abroad or given as gifts become known to us. Furthermore the number of Christ images increases by another 448 if we add the huge silkscreened canvases *Christ 112 Times*.

Warhol's numerous studies of Leonardo's Christ certainly relate to the religious ambience of his home and of St. John Chrysostom Byzantine Church, where Andy and his family attended services regularly. With these first-generation immigrants the church played a significant role, drawing together the Carpatho-Rusyn miners and their families in an environment where the familiar liturgy and icons and their common language gave a cohesion and comfort to these newly arrived Americans. Andy would have seen from childhood latter-day copies of the Byzantine Christ on every iconostasis screen in church and in the homes of Byzantine Catholic families.

The variety and large number of Warhol's transformations of the Leonardo Christ (fig. 77) are astonishing. The large series of Christ images (fig. 78) that are silkscreened over pieces of colored paper that have been adhered to a heavy sheet of background paper are lyrical and reverential. Isolated from the actions of the apostles, and with the setting of the room minimized, the focus on the Christ is intensified. We become aware of the inward and remote expression of his face and how it contrasts with the self-offering gestures of his hands. The Christ image seems closer here to a famous drawing from Leonardo's studio than to the damaged image in Leonardo's mural as it appears today. The geometric patches of color through which we look at the Christ image appear to be transparent. They provide a twentieth-century

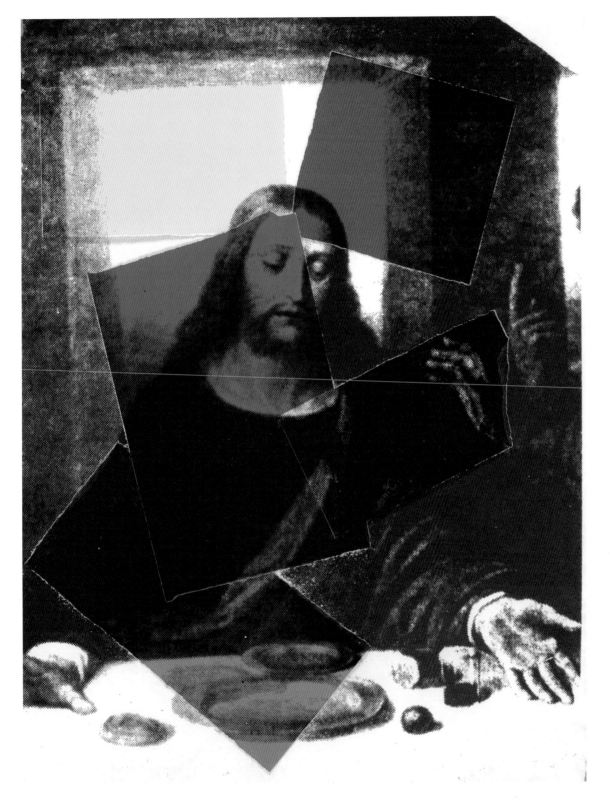

78. Andy Warhol, *The Last Supper* (Christ), 1986. Silkscreen ink and collage on paper, 31½ x 23¾ in.

device through which we see the fifteenth-century Christ. The result is that we see afresh and anew the image that has been made banal by the ubiquity of poor reproductions. These frontal images of Christ also bring us closer to the icons of Byzantine Orthodoxy, which Warhol knew from his early years in Pittsburgh.

Sixty Last Suppers

Sixty Last Suppers (fig. 79), in which the Leonardo image is repeated vertically six times and horizontally ten times, returns to the grid compositions of Warhol's Pop paintings. On first viewing, it seems a handsome abstract composition, but the identity of the basic image asserts itself surprisingly quickly. The painting is almost ten feet high and more than thirty-two feet wide and is one of Warhol's most beautiful and involving late paintings. The viewer is impelled into a physical relationship with it, for the entire painting can be seen only by stepping way back from the wall where it hangs: then, having studied the grid pattern of repeated images, we are drawn forward to examine the individual images—how they are joined—how the blackness of the left and back walls in the repeated rooms makes the light on the right wall and the light about the sixty-times-repeated Christ seem phosphorescent. Moving away again, the black-and-white pattern has a gentle rhythm of repetition that becomes mesmerizing.

During the first decades of Warhol's life he was weekly in the presence of the large iconostasis screen of St. John Chryostom's Byzantine Church with his family at Sunday services. The multiplicity of images on the iconostasis screen provides something of the same ambience that one experiences in the presence of the veritable wall of images that is the *Sixty Last Suppers.*

Serial repetition as a strategy has been used by mid-twentieth-century artists such as Jasper Johns, and the grid composition by artists such as Sol LeWitt and Agnes Martin. Monotonous repetition, which at times achieves an incantatory expressiveness, is also used by composers such as John Cage and those he influenced. Repetition has been used also in literature by Gertrude Stein, who, as has been already noted, was particularly admired by Warhol. Warhol discussed his use of the repeated image in an interview in 1982:

> I just like to do the same thing over and over again. Every time I go out and someone is being elected president or mayor or something, they stick their images all over the walls and I always think I do those. . . . I always think it is my work. It's a way of expressing one-self. All my images are the same . . . but very different at the same time. . . . They change with the light of colors, with the times and the moods. . . . Isn't life a series of images that change as they repeat themselves?[15]

Warhol did not see his paintings as automatic repetitions of identical images, but noted that the images "change with the light and colors, with the times and the moods," adding a query that suggests his own perception of the flow of visual images and the passage of time—of mutability and transience: "Isn't life a series of images that change as they repeat themselves?"

In the *Sixty Last Suppers* the repetitions are not identical in the density of the black paint and the clarity of definition of the individual images. As the viewer studies this majestic painting, the eye and the imagination suddenly shift and see these upper rooms as all within one building that has a wall removed, exposing the multiple enactments of this sacramental meal.

As the viewer steps back from these large paintings, it is the mysterious power of their beauty that is experienced. Art critics of our day seldom use the word beauty, for one of the major thrusts of modernism in art and criticism was to dispense with beauty in its classical usage. Beauty has been acceptable in our day when it is affectless, or when it is coupled with irony. Warhol ignored this aspect of the avant garde, and throughout his career he created many paintings of enthralling beauty—the icon-like quality of the *Gold Marilyn Monroe,* the series of paintings called *Shadows,* the *Skull* series, and many paintings in the *Death and Disaster* series, culminating in the *Last Supper* paintings.

In these last paintings the formerly cool and distanced artist finally created paintings in which his concealed religiosity flowed freely into his art. Technically he achieved a freedom and a virtuosity that are analogous to the mastery seen in the late work of some Renaissance, baroque, and nineteenth-century masters. Like the virtuosity of some earlier artists, Warhol's skill served a deepened spiritual vision. Heiner Friedrich, who was one of Warhol's first patrons, proposes an analogy to Titian.[16] In the Milan paintings, Warhol himself was engaged at a level deeper than his habitual secret piety. The pink and yellow *Last Suppers* draw the viewer into the moment, held in suspension, when the announcement of betrayal has been made but the promise of redemption is implicit.

In Leonardo's mural the apostles and Christ are larger in scale than the viewer, and the drama takes place high above us on the wall. We imagine ourselves witnessing the event in the upper room. Warhol, by reducing the scale of the paintings and hanging them low, makes accessible and intimate the protagonists in the scene. We read the painting, moving along its length, studying the faces and gestures in the first scene, and then again as it is repeated. The repetition and our physical movement are akin to the cadence and repetitions of liturgy.

The *Last Supper* paintings formed one of Warhol's largest and most complex series. It is also one of the largest groups of paintings with religious subject matter by an American artist of our century, indeed, of our three-hundred-year history. Only John Singer Sargent's murals for the Boston Public Library on the grandiose theme, "The Development of Religious Thought from Paganism to Christianity," approaches Warhol's series in size. Warhol's cycle of paintings ranges from the freely painted boxing bags

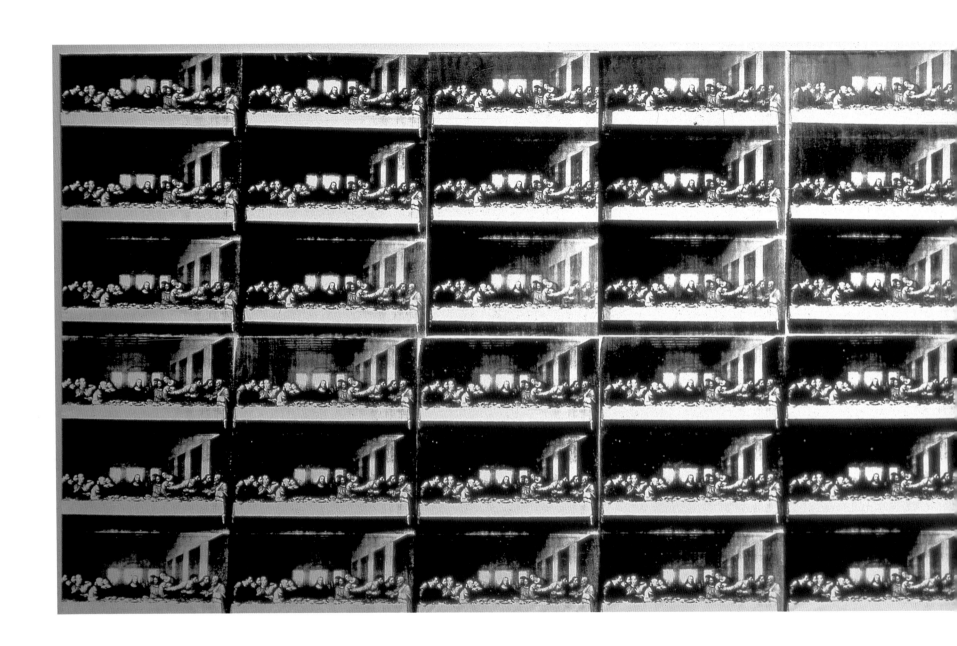

The Religious Art of Andy Warhol

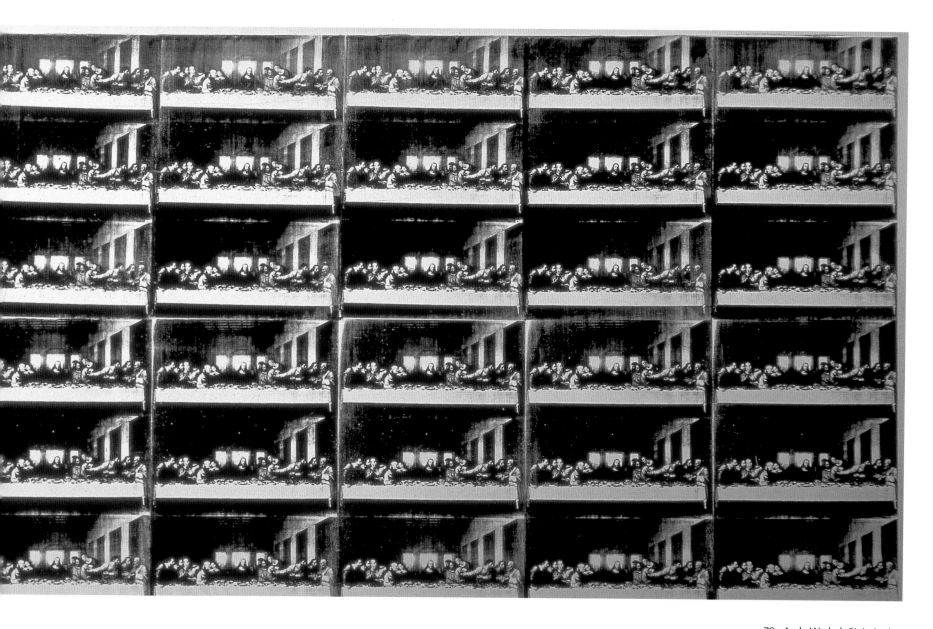

79. Andy Warhol, *Sixty Last Suppers,* 1986. Synthetic polymer on silkscreen ink on canvas, 116 x 393 in.

and the ink drawings of the Christ and the apostles to the subtle interplay of light and shadow and unexpected juxtapositions of color of the *Last Supper* paintings. In content, they range from the startling and playful *Last Supper (Dove)* to the somber and mysterious *Camouflage Last Supper*. Warhol's recreations infuse Leonardo's familiar image, which had become a cliché, with new spiritual resonance. In these last works Warhol's technical freedom and mastery and his deepened spiritual awareness resulted in paintings that evoke what the romantics and the abstract expressionists called "the Sublime." His final series on the Last Supper (fig. 80) is the grandest and most profound cycle of paintings by this prolific, enigmatic, and complex artist, whose importance defies the test of time.

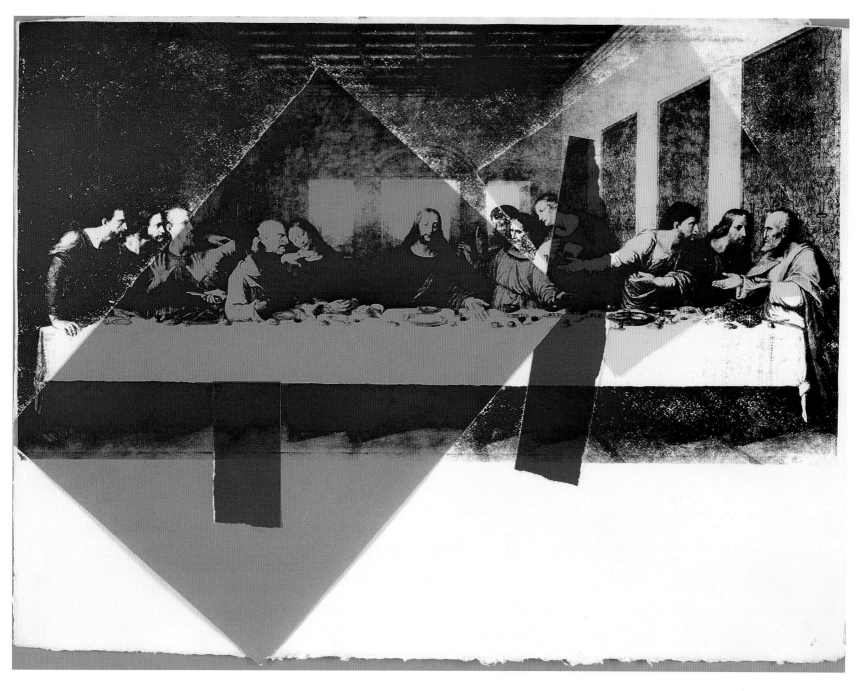

80. Andy Warhol, *The Last Supper*, 1986. Screenprint and colored graphic art collage paper, 23³/₄ x 31⁵/₈ in.

Notes

Chapter 1

1. John Richardson, "Eulogy for Andy Warhol," given on the occasion of his memorial service at St. Patrick's Cathedral in New York City, April 1, 1987. Published in *Andy Warhol: Heaven and Hell Are Just One Breath Away! Late Paintings and Related Works, 1984-1986,* by Charles Stuckey et al., exhibition catalogue, Gagosian Gallery (New York: Rizzoli, 1992), pp. 140–41.

2. Henry Geldzahler, "A Collective Portrait of Andy Warhol," in *Andy Warhol: A Retrospective,* ed. Kynaston McShine (New York: Museum of Modern Art, 1989; distributed by Bullfinch Press, Little, Brown & Co., Boston), p. 427.

3. Henry Geldzahler, "The Recording Angel," in *Andy Warhol: A Memorial,* curated by Henry Geldzahler, Dia Art Foundation, Bridgehampton, New York, July 4–August 16, 1987, n.p.

4. Victor Bockris, *Warhol* (London: Penguin Books, 1989), p. 7.

5. Ibid., p. 8

6. Ibid., p. 9.

7. Paul Warhola, telephone conversation with author, January 10, 1997.

8. Saint Vitus' Dance is a term for chorea, a disorder of the nervous system characterized by the irregular, jerking movements caused by involuntary muscular contractions.

9 Andy Warhol, *The Philosophy of Andy Warhol (From A to B and Back Again)* (New York: Harcourt Brace Jovanovich, 1975), p. 21.

10. Bockris, *Warhol,* p. 40.

11. Ibid., p. 44.

12. Ibid., p. 51.

13. Bob Colacello, *Holy Terror: Andy Warhol Close Up* (New York: HarperCollins, 1990), p. 118.

14. David Bourdon, *Warhol* (New York: Harry Abrams, 1989), p. 28.

15. John Richardson, "The Secret Warhol: At Home with the Silver Shadow," *Vanity Fair,* July 1987, p. 125.

16. Patrick S. Smith, *Warhol: Conversations about the Artist* (Ann Arbor, Mich.: U.M.I. Research Press, 1988), p. 342.

17. Andy Warhol and Pat Hackett, *Popism: The Warhol 60's* (New York: Harcourt Brace Jovanovich, 1980), p. 5.

18. Bourdon, *Warhol,* p. 38.

19. Owned now by her eldest son, Paul Warhola.

20. David Bourdon, "Warhol Starting Out," in *The Andy Warhol Collection: Collectibles, Jewelry, Furniture, Decorations, Paintings,* Sotheby's Auction Catalogue, Friday, April 29, 1988, and Saturday, April 30, 1988, n.p.

21. Smith, *Warhol: Conversations,* p. 43.

22. Warhol, *Philosophy of Andy Warhol,* p. 10.

23. Ibid., pp. 147–48.

24. Trevor Fairbrother, "Tomorrow's Man," in *Success Is a Job in New York: The Early Art and Business of Andy Warhol,* exhibition catalogue, Grey Art Gallery and Study Center, New York University, and other locations, 1989–90, p. 55.

25. Warhol and Hackett, *Popism,* p. 12.

26. A group of these designs is in the collection of the Andy Warhol Museum in Pittsburgh. Some are preliminary sketches, but several are completed designs, two with the Three Magi and Holy Family. The Museum of Modern Art Retrospective published drawings for an angel and for the Golden Hand Holding a Crèche. See *Andy Warhol: A Retrospective* (n. 2 above), pls. 52, 53.

27. Robert Rosenblum, "Warhol as Art History," in *Andy Warhol: A Retrospective* (n. 2 above), p. 36.

28. Warhol and Hackett, *Popism,* p. 3.

29. Ibid., p. 22.

30. Hilton Kramer, in "Symposium on Pop Art," December 13, 1962, The Museum of Modern Art, New York; text reprinted in *Arts Magazine,* April 1963.

31. Peter Selz, "Pop Goes the Artist," *Partisan Review,* Summer 1963.

32. Bockris, *Warhol,* p. 166.

33. Arthur C. Danto, "The Philosopher as Andy Warhol," in *The Andy Warhol Museum: Essays by Arthur C. Danto, Mark Francis, et al.* (Pittsburgh: The Andy Warhol Museum, 1994; distributed by Art Publishers, New York), p. 83.

34. Andy Warhol, *The Andy Warhol Diaries,* ed. Pat Hackett (New York: Warner Books, 1989), pp. 703, 777.

35. Ibid., p. 777.

36. Warhol, *Philosophy,* pp. 24, 25.

37. Richardson, "The Secret Warhol," p. 126.

38. Warhol and Hackett, *Popism,* p. 273.

39. Colacello, *Holy Terror,* p. 70.

40. Warhol and Hackett, *Popism,* p. 279.

41. Colacello, *Holy Terror,* p. 278.

42. Neil Printz, "Painting Death in America," in *Andy Warhol Death and Disasters,* by Walter Hopps et al., The Menil Collection (Houston: Fine Arts Press, 1988), p. 19.

43. Richardson, "The Secret Warhol," p. 70.

44. Steven Aronson said that "Warhol bought dozens of 18th and 19th century Spanish Colonial crucifixes and santos, three or four at a time" (*Sale of the Warhol Estate,* Sotheby catalogue, n.p.).

45. Fr. Sam Matarazzo, interview with author at St. Vincent's Priory, February 20, 1994.

46. Colacello, *Holy Terror,* p. 437.

47. Ibid., p. 119.

48. Ibid.

49. Warhol, *Diaries,* p. 343.

50. Ibid., p. 275-76.

51. Ibid., p. 596.

52. Stephen Koch, *Stargazer: The Life, World, and Films of Andy Warhol* (New York: Marion Boyars, 1991), p. ii.

53. Ibid.

54. Warhol, *Diaries,* p. 643.

55. Richardson, "The Secret Warhol," p. 126.

56. Christopher Makos, *Warhol: A Personal Photographic Memoir* (New York: New American Library, 1988), p. 53.

57. Vincent Fremont, interview with the author, January 7, 1993.

58. Bockris, *Warhol,* p. 598.

59. Ibid., p. 604.

60. Ibid.

61. Andy Warhol, *America* (New York: Harper & Row, 1985), p. 129.

Chapter 2

1. Bob Colacello, *Holy Terror: Andy Warhol Close Up* (New York: HarperCollins, 1991), p. 462.

2. Andy Warhol, "Guns, Knives, and Crosses," exhibition at Galleria Fernando Vijande, Madrid, December 16, 1982 to January 21, 1983, n.p.

3. Robert Rosenblum, "Warhol as Art History," in *Andy Warhol: A Retrospective,* The Museum of Modern Art (Boston: Little Brown & Co., 1989), p. 33.

4. Millard Meiss, "The Madonna of Humility," in *Painting in Florence and Sienna After the Black Death* (Princeton, N.J.: Princeton University Press, 1951), p. 146.

5. Andy Warhol, *The Andy Warhol Diaries,* ed. Pat Hackett (New York: Warner Books, 1989), p. 342 (entry for November 10, 1980).

6. Christopher Makos, *Warhol: A Personal Photographic Memoir* (New York: New American Library, 1988), p. 53.

7. They were acquired for the Lone Star Foundation, which later became the Dia Art Foundation.

8. Andy Warhol, "Painter Hangs Own Paintings," in *Warhol: Shadows,* The Menil Collection, 1987, n.p.
9. Patrick S. Smith, *Warhol: Conversations about the Artist* (Ann Arbor, Mich.: U.M.I. Research Press, 1988), p. 283.
10. Ibid., p. 354.

Chapter 3

1. Andy Warhol and Pat Hackett, *Popism: The Warhol 60's* (New York: Harcourt Brace Jovanovich, 1980), p. 17.
2. Bennard B. Perlman, "The Education of Andy Warhol," in *The Andy Warhol Museum: Essays by Arthur C. Danto, Mark Francis, et al.* (Pittsburgh: The Andy Warhol Museum, 1994; distributed by Art Publishers, New York), p. 157.
3. *Andy Warhol: A Memorial,* curated by Henry Geldzahler, July 4–August 16, 1987, Dia Art Foundation; distributed by Bullfinsh Press, Little, Brown & Co., Boston, p. 6.
4. Reconstructed as: Victor Bockris, *Warhol* (London: Penguin Books, 1989), p. 160.
5. Gene Swenson, "What is Pop Art?" *Art News 62* (November 1963): 60–63.
6. Trevor Fairbrother, "Skulls," in Gary Garrels, *The Work of Andy Warhol* (Seattle: Bay Press, 1989), p. 101.
7. *Andy Warhol Death and Disasters,* by Walter Hopps et al., The Menil Collection (Houston: Fine Arts Press, 1988), p. 9.
8. Fairbrother, "Skulls," p. 94.
9. Ibid., p. 96.
10. Patrick S. Smith, *Warhol: Conversations about the Artist* (Ann Arbor, Mich.: U.M.I. Research Press, 1988), p. 278. Warhol chose three of the *Skull* photos, making tracings of the projected images. These tracings became the basis for a portfolio of four screen prints (one image was in reverse). The three-quarter view of the skull was used for one of the most profound and most beautiful of Warhol's late series, a series that was screen printed in three sizes, 15 x 19 inches, 6 x 6.5 feet, and also on huge canvases 11 x 12 feet.
11. Ibid., p. 354.
12. Ibid., p. 353.
13. Alan Solomon, *Andy Warhol,* exhibition catalogue, Institute of Contemporary Art, Boston, October 1 to November 6, 1966, n.p.

Chapter 4

1. John Warhola, interview with the author, October 2, 1994, in Pittsburgh.
2. Leo Steinberg, "The Seven Functions of the Hands of Christ," in *Art, Creativity and the Sacred,* ed. Diane Apostolos-Cappadona (New York: Crossroad, 1984), p. 55.
3. Rupert Smith in *The Andy Warhol Collection: Collectibles, Jewelry, Furniture, Decorations, Paintings,* Sotheby's Auction Catalogue, Friday, April 29, 1988, and Saturday, April 30, 1988, item number 927.
4. *Cyclopedia of Painters and Paintings,* vol. 3, ed. John Denison Champlin, Jr., critical editor Charles C. Perkins (New York: Charles Scribner's Sons, 1913), p. 32.
5. Jay Shriver, interview with the author, October 30, 1995, at his studio, New York.
6. Heiner Friedrich, conversation with the author, December 13, 1995, in New York.
7. Steinberg, "Seven Functions of the Hands of Christ," p. 50.
8. Andy Warhol, *The Andy Warhol Diaries,* ed. Pat Hackett (New York: Warner Books, 1989), p. 386.
9. Charles Stuckey, "Heaven and Hell Are Just One Breath Away," in *Andy Warhol: Heaven and Hell Are Just One Breath Away! Late Paintings and Related Works, 1984–1986,* by Charles Stuckey et al., exhibition catalogue, Gagosian Gallery (New York: Rizzoli, 1992).
10. Sigmund Freud, *Leonardo da Vinci: A Study in Psychosexuality* (New York: Random House, 1947).
11. Warhol, *Diaries,* p. 600.
12. Jay Shriver, interview with the author, October 30, 1995, in his studio, New York.
13. Andy Warhol and Pat Hackett, *Popism: The Warhol 60's* (New York: Harcourt Brace Jovanovich, 1980), p. 195.
14. *Raid the Icebox 1: With Andy Warhol,* An Exhibition Selected from the Storage Vaults of the Museum of Art, Rhode Island School of Design, Museum of Art, Rhode Island School of Design, 1969.

15. The individual images look like photographic negatives, the outlines being white and the faces black. Warhol had used this reversal of values in a series of portraits of Marilyn Monroe and other popular images depicted by him originally in the sixties.

16. George Steiner, *Real Presences* (Chicago: University of Chicago Press, 1989), p. 4.

Chapter 5

1. Vincent Fremont, interview with the author, October 10, 1993, Andy Warhol Foundation, New York.

2. Warhol was referring here to the large hand-painted and screen-printed *Last Supper* paintings. See Taylor Hall, "The Last Interview: Andy Warhol," Flash no. 133 (April 1987): 41. For the contents of the Milan exhibition, see Alexandre Iolas, *Warhol Il Cenacolo* (Milan: Edicioni Philippe Daverio, 1987).

3. Two of the large hand-painted *Last Supper* paintings and three of the silkscreen paintings were shown, together with a group of collaged prints, at the Dia Center for the Arts, New York, September 16, 1994, to June 1995. The largest and most important showing of these works, *Andy Warhol: The Last Supper,* was held in Munich from May 27 to September 27, 1998, at the Haus der Kunst. The catalogue, published in German and English editions by the Staatsgalerie Moderner Kunst in 1998, has fine plates and essays by Carla Schulz-Hoffmann, Corinna Thierolf, Cornelia Syre, as well as my first chapter from the present work, "Another Andy Warhol."

4. Bob Colacello, *Holy Terror: Andy Warhol Close Up* (New York: HarperCollins, 1990), p. 486.

5. Pierre Restany, "Andy Warhol: A Mauve-Tinged Platinum Wig," in *Andy Warhol: An Exhibition,* curated by Jacob Baal-Teshuva, May–June 1989 (New York, Magidson Fine Art, 1989), n.p.

6. See Leo Steinberg, "Leonardo's *Last Supper,*" The Art Quarterly 36 (1973): 297–410. Also Ludwig H. Heydenreich, *Leonardo: The Last Supper* (New York: Viking Press, 1974).

7. Rainer Crone, "Form and Ideology: Warhol's Techniques from Blotted Line to Film," in *The Work of Andy Warhol,* ed. Gary Garrels (New York: Dia Art Foundation, 1989).

8. All the works shown in the Milan exhibition were silkscreened, like Warhol's major Pop paintings from 1962 on.

9. Heydenreich, *Leonardo,* p. 101.

10. Rupert Smith, in *The Andy Warhol Collection: Collectibles, Jewelry, Furniture, Decorations, Paintings,* Sotheby's Auction Catalogue, Friday, April 29, 1988, and Saturday, April 30, 1988, item number 927.

11. Andy Warhol, *The Andy Warhol Diaries,* ed. Pat Hackett (New York, Warner Books, 1989), p. 124.

12. Mark Francis, wall label in the Andy Warhol Museum in Pittsburgh.

13. Father Sam Matarazzo, interview with author, February 20, 1994, at St. Vincent Ferrer Priory, New York. Bob Colacello, the editor of Andy's magazine *Interview* and his biographer, reported that "Andy went to church every Sunday as long as I knew him. He said Mass took too long, and confession was impossible because he was sure that the priest would recognize him through the screen and gossip about his sins, and he never took communion because he knew it would be sacrilege to do so without confessing" (*Holy Terror,* p. 70).

14. Gertrude Stein, *Picasso* (Boston: Beacon Press, 1959), p. 11.

15. Andy Warhol, *Warhol Versus De Chirico* (New York: Marisa Del Re Gallery, 1982), p. 53.

16. Heiner Friedrich interview with the author, December 13, 1995, Gallery of the Dia Center for the Arts, New York.

Photographic Acknowledgments

The Andy Warhol Museum, Pittsburgh. All works listed are in the Founding Collection. Contribution of The Andy Warhol Foundation for the Visual Arts: figs. 16, 21, 23, 24, 35, 39, 50, 64, 67, 73

The Archives of the Andy Warhol Museum: figs. 3, 15, 63, 72

The Archives of the Andy Warhol Museum. Photograph by Matt Wrbican: fig. 72

From The Andy Warhol Museum. © Carnegie Museum, 1992: fig. 13

© 1998 The Andy Warhol Foundation for the Visual Arts/ARS, NY: figs. 5, 6, 8, 10, 11, 16, 21, 22, 23, 24, 25, 26, 28, 30, 32, 34, 35, 36, 40, 41, 42, 44, 45, 46, 47, 48, 51, 52, 56, 57, 58, 59, 60, 62, 64, 65, 66, 67, 68, 73, 74, 75, 76, 78, 79, 80

© 1998 The Andy Warhol Foundation for the Visual Arts/Art Resource, NY: figs. 6, 8, 11, 21, 22, 25, 26, 28, 29, 30, 31, 32, 34, 36, 37, 43, 44, 45, 46, 48, 51, 56, 58, 59, 60, 62, 64, 65, 68, 70, 74, 75, 77, 78, 79, 80

Photographs by John Warhola: figs. 4, 20

Photograph by Paige Powell: fig. 12

Photographs by Evelyn Hofer: figs. 15, 53

Photograph by Christopher Makos: fig. 71

Photographs by Jane Daggett Dillenberger: figs. 19, 69

Photographs by Lois Lord: figs. 40, 41

National Gallery, London: figs. 31, 49

Courtesy The Robert Miller Gallery, New York: figs. 58, 66

The Metropolitan Museum of Art, Purchase, Vera G. List Gift, 1987: fig. 76

Sotheby's, New York: fig. 14

National Gallery of Art, Washington DC, Samuel H. Kress Collection: fig. 33

The Albertina Collection, Vienna, Art Resource, NY: fig. 21

The Vatican Museums, Vatican City, Foto Felici: fig. 17

Erich Lessing/Art Resource, NY: figs. 6, 37

Scala/Art Resource, NY: fig. 29, 70

Alinari/Art Resource, NY: fig. 77

Giraudon/Art Resource, NY: figs. 11, 43

Locations of the Works of Arts